People

AMAZING PETS!

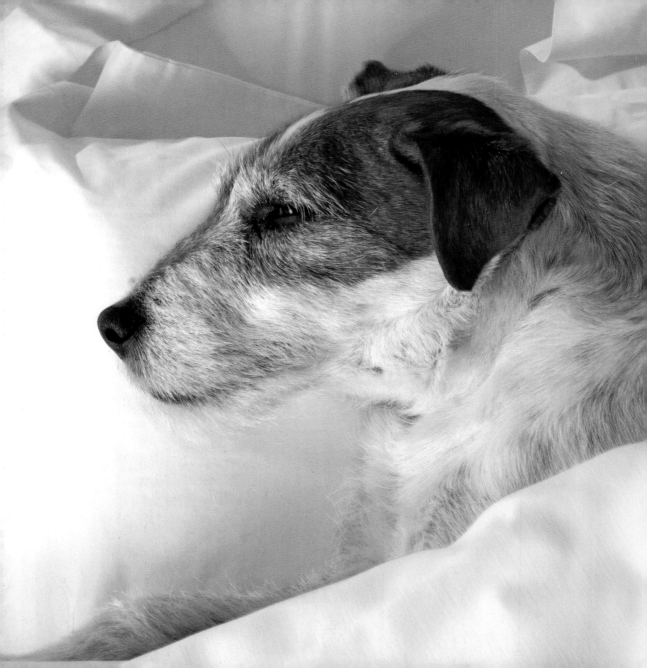

CONTENTS

DOG STAR
Filming done, a long awards season over, Uggie, star of the Oscar-winning *The Artist,* takes a well-deserved nap.

JUST SAY WHOA:
AN INTRODUCTION

PEOPLE is, of course, about people. Except when it's about pets. And other animals. Which is pretty often: Since 1974 the magazine has run hundreds of stories about odd pets, brave pets, record-setting pets and awe-inspiring animals. Skydiving dachshunds? Check. Sweaters for chilly penguins? Of course. Norman, the blind Lab who saved a girl from drowning? Binti-Jua, the gorilla who carried an injured boy to safety? A guy who tastes pet food for a living? Television custom-made for cats? Kim Kardashian kissing a pig? Yes, yes, yes, yes and yes. Horses with magnificently coiffed manes? Been there, combed that (that's Florence the mare, right, doing a creditable impersonation of '40s film star Barbara Stanwyck).

From camelpoodles to celebrity pets, pet hippos to a hero parrot, PEOPLE: *Amazing Pets* offers the pick of the litter from the ample, amusing and sometimes amazing archives of the weekly magazine and people.com.

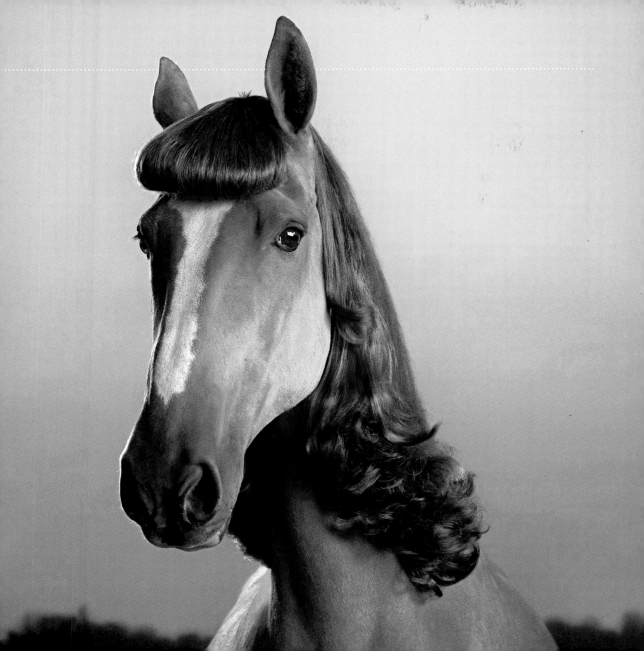

HAIRDOS

for
HORSES!

Why, exactly? Because, frankly, Australian photographer Julian Wolkenstein just thought it would be fun. The horses, whose weaves required four hours each, enjoyed it too. "They loved the grooming and being fawned over," says Wolkenstein. And the thrill, of course, of becoming mane attractions.

BEHOLD: THE
CAMELPOODLE!

Basketball has Michael Jordan. Golf, Tiger Woods. But in the world of extreme poodle grooming, two names are spoken in hushed, reverent tones: Sandy Hartness and her inspiration and living canvas, Cindy, an extremely tolerant, ready-for-anything standard poodle. Over the years, Cindy has been dyed, coiffed and even befeathered to look like everything from a dragon to a Teenage Mutant Ninja Turtle. "She loves it," says Hartness, who has a grooming business, Sandy Paws, in Yucca Valley, Calif. "When she's colored or decorated, she's so much more lively and outgoing. She'll run up to people like, 'Look at me!' Her whole personality changes."

...and the
PEACOCKPOODLE!

On her website, Hartness notes that she uses only pet-safe products and that "Cindy will look like this for only a few hours. After the contest Cindy will be clipped into a normal poodle haircut."

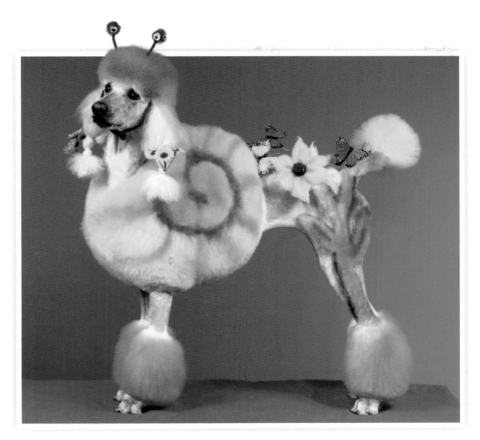

...and the
SNAILPOODLE!

This entry landed Hartness and Cindy on the cover
of *Groomer to Groomer* magazine.

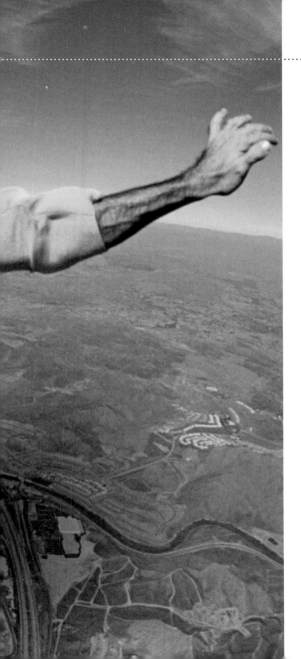

BRUTUS,
THE SKYDIVING DACHSHUND!

He flew through the air with the greatest of ease, and a memorably wicked grin. When PEOPLE first caught up with Brutus in 1995, the miniature dachshund was already on his 34th jump (always strapped by a special harness to his owner, who said he'd cleared Brutus's unusual hobby with the Arizona Humane Society). Brutus would go on to make more than 100 jumps, often at air shows. "This is one dedicated dude," said his owner. "He's fearless." No question: A born wiener.

I LOVE YOU TOO, YA BIG APE!

In 1985, Koko the sign-language-proficient gorilla and Lipstick, her pet kitten, gazed across the evolutionary gap and found friendship.

OUR LOVE IS HERE TO STAY!

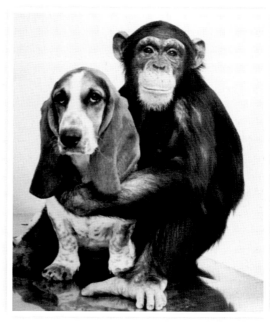

Hoping to teach Sheba, a somewhat spoiled 6-year-old chimpanzee, a little about responsibility, Sally Boysen, an associate psychology professor at Ohio State University, introduced her to Skylar the basset hound. Sheba learned to care for Skylar and came to regard her as her pet.

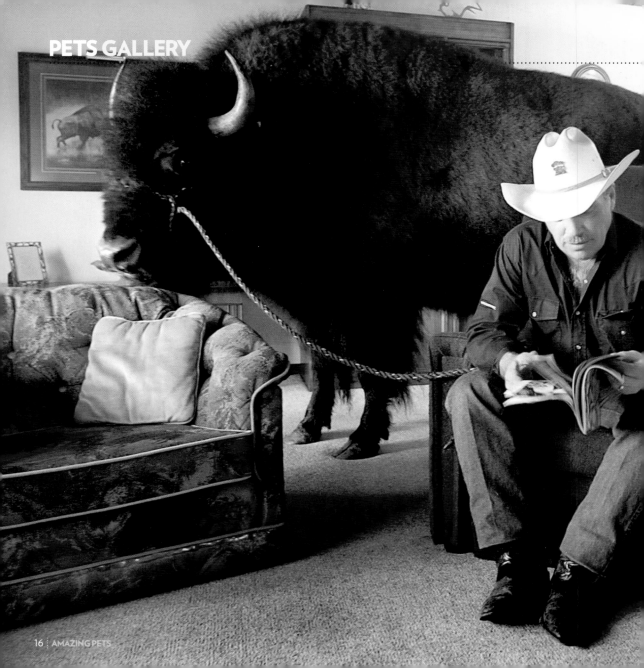

OH, GIVE ME A HOME
WHERE THE BUFFALO ROAMS!

Jim and Linda Sautner, who own a Canadian buffalo ranch, first let Bailey in after his mother abandoned him as a calf, and everything—including their now 1,600-lb. pet—just grew from there. Bailey often comes in to watch TV; if there's an occasional broken lamp, that's just a small item to add to the buffalo bill.

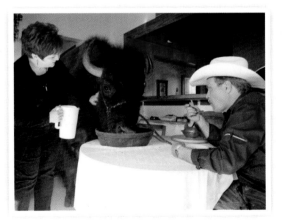

LOUNGE LIZARDS!

How much does the former Henry Schifberg love lizards? This much: In 1986 he officially changed his name to Henry Lizardlover. A passionate herpetoculturist, he shares his L.A.-area home with dozens of reptiles, including a number of iguanas, for whom he has built tiny couches. Why? Because, as his name makes clear, he loves lizards. Also, he notes, "They're chick magnets."

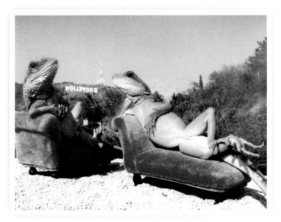

EVERYBODY FREEZE!

Posing for a PEOPLE photo shoot in 1987, comedian Tracey Ullman learned one of the dangers of owning small, nervous dogs.

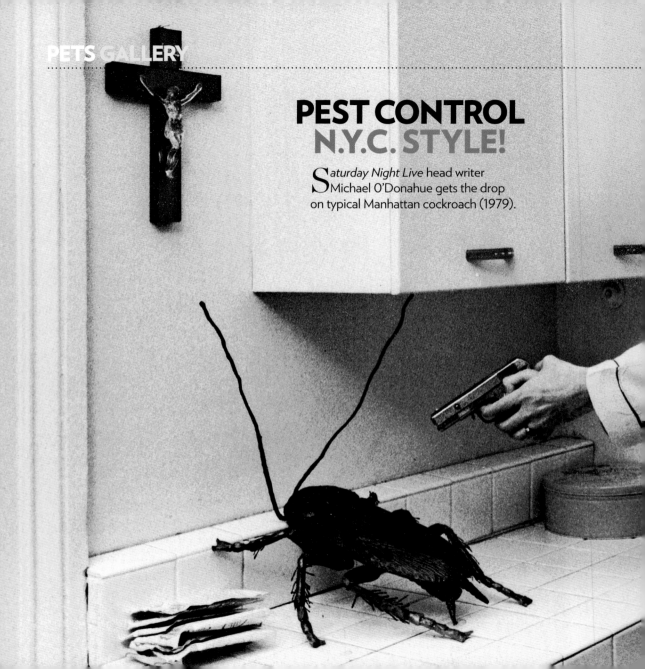

PEST CONTROL
N.Y.C. STYLE!

Saturday Night Live head writer Michael O'Donahue gets the drop on typical Manhattan cockroach (1979).

EINSTEIN:
THE WORLD'S SMALLEST HORSE

Only 14 inches high at birth in 2010, Einstein, a minihorse owned by Rachel Wagner and Charlie Cantrell, is believed to be the smallest horse in the world. Said one of more that 4,000 people who lined up to see the newborn at Tiz A Miniature Horse Farm in Barnstead, N.H.: "I could have stuck him in my purse."

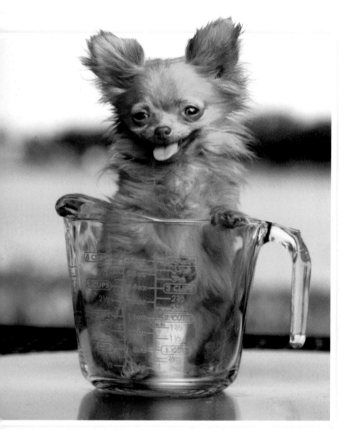

TINY DANCER:
BARELY
TWO CUPS
OF CANINE

B orn the size of a human thumb, Dancer, a Chihuahua owned by Jenny Gomes of Okahumpka, Fla., had hopes of making the *Guinness World Records* as the world's smallest dog. Alas, it was not to be: Dancer grew to a comparatively mammoth 5 inches tall at the shoulder, and was undercut by Ducky of Massachusetts, at 4.9 inches, and Kentucky's Boo-Boo, 4 inches even.

THE ULTIMATE IN CANINE CUISINE!

DELI SPECIAL 299
TURKEY A LA FIDO

DO
DE
S

CHEESE
YOUR DOG WILL LOVE

ALL NAT

vital 30

H²O

CHOWHOUND

Liver mousse cakes? Catnip casseroles? "We do *not* serve dog and cat food," said Gloria Lissner, owner of Chicago's Famous Fido's Doggie Deli. "We serve food to dogs and cats."

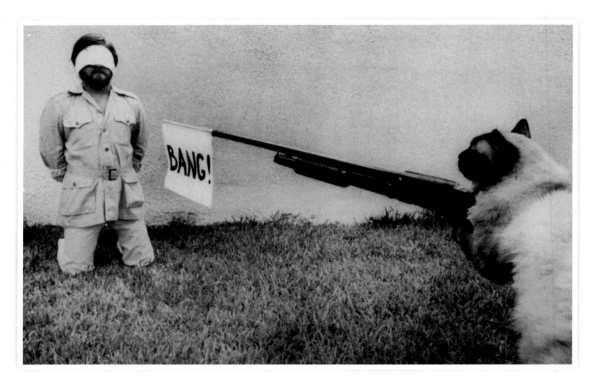

TAKE THAT, HAIRBALL!

An offended feline takes aim at Simon Bond, author of the novelty bestseller *101 Uses for a Dead Cat*.

I'M ALL EARS. REALLY.

Yoda the four-eared cat gets called names—Devil Cat, Beelzebub— but owner Valerie Rock loves him just the same: "He is a very affectionate and social cat. He's perfectly normal in every other way."

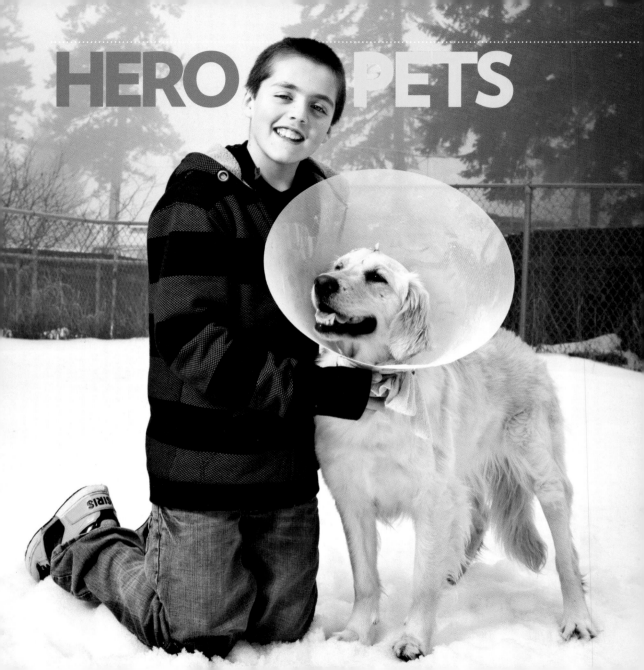

HERO PETS

Trouble strikes—who ya gonna call? How about
Norman the Lab, Daisy the pig or Sunshine the parrot?
Heroes, it's clear, don't have to be human

ATTACKED BY A COUGAR,
SAVED BY AN ANGEL

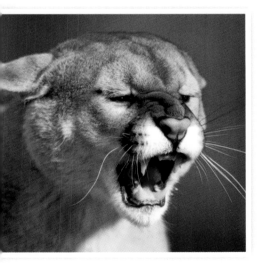

Eleven-year-old Austin Forman was loading firewood into a wheelbarrow behind his home in Boston Bar, British Columbia, when a mountain lion appeared and charged toward him. Austin's dog, a golden retriever named Angel, leapt up and took on the cat. Austin sprinted inside, and his mother called 911; minutes later, RCMP constable Chad Gravelle arrived and shot the big cat dead. He pried Angel's head from the cougar's jaws, but the dog seemed lifeless.

And then, "the next thing we knew, she sucked in a big breath of air and started coughing blood," said Austin's mom, Sherri Forman. Six days later—despite stitches, staples and two dozen puncture wounds—Angel was well enough to jump up and greet Austin. Said Gravelle: "She's pretty much the bravest dog I've every seen." Added Austin, "My grandpa just finished building her a doghouse with an insulated floor. She's going to be spoiled rotten from now on."

NORMAN : BLIND AND BRAVE

Though blind for nearly two years from retinal atrophy, Norman, a 4-year-old yellow lab, still loved to go for walks along the Necanicum River in Seaside, Ore. "He lives to go to the beach," said owner Annette McDonald. "He runs, and if he's about to hit something, I'll shout, 'Easy! Easy!' and he slows down."

But on one such walk in 1996, Norman "flew off, ignoring my calls," said Annette. "He looked like he was on a mission." Minutes earlier Lisa Nibley, 15, and her brother Joey, 12, had been caught in the Necanicum's current. Joey managed to make it safely to shore, but Lisa, frightened, was struggling, and Norman homed in on her screams. "He swam after her, and my jaw just dropped," said Annette. Norman reached Lisa (left), who grabbed his tail, and the two headed back to shore. "I don't know how much longer I could have lasted," Lisa said. After hearing Lisa's story, her mother, Elaine, who had been on the far side of the river, "started shaking and crying," recalled Lisa. Afterward, she hung a photo of Norman over her bed, "up there with pictures of all my friends," she said. "He's my guardian angel."

A REAL-LIFE LASSIE
"When the helicopter appeared," said Bosch, who was trapped in his SUV until Honey saved the day, "it was surreal."

HONEY, THE HERO PUP
WHO WOULDN'T SHUT UP

Blinded by the sun while backing his SUV down the hilly driveway of his Nicasio, Calif., home, Michael Bosch plunged 50 feet down a wooded slope. Trapped inside the overturned vehicle, his leg pinned by a tree, the 63-year-old real-estate broker managed to push Honey, his cocker spaniel, through a hole in a broken window. "Go home, Honey, go home!" he told her.

Honey disobeyed, splendidly. She went a quarter mile to the nearest neighbor, Robin Allen, who, returning seven long hours after the accident, found the dog running circles in his driveway. "She seemed frenetic," said Allen. "She was obviously trying to tell me something because she wouldn't let me catch her."

Eventually Allen caught the dog and returned her to the address on her ID tag—where he heard the trapped Bosch yell from his car. Says Bosch, who suffered five broken ribs: "I probably wouldn't be alive today if it weren't for Honey."

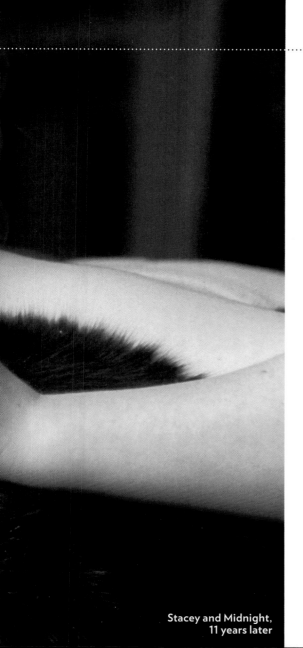

THE CAT'S MEOW: MIDNIGHT RESCUES AN AILING BABY

Six-week-old Stacey Rogers was born premature, so when she came down with a cold, her mom rushed her to the doctor. "He thought I was overreacting," Bernita Rogers recalled. "He told me to just put a humidifier in her room."

Back home, as Stacey napped, Bernita tried to relax in another room, but Midnight, the family cat, wouldn't let her. "He was being such a nuisance," she says. "He kept jumping on my lap and batting my legs. This wasn't his usual behavior." Shooed away, Midnight persisted. "I heard him through the baby monitor [in the nursery]—an eerie, moaning sound," says Bernita. Alarmed, she ran to Stacey's room, where the frantic cat was perched atop the dresser—and Stacey was blue and gasping for air. Taken to the hospital, she was resuscitated from respiratory failure and diagnosed with a viral infection. If not for Midnight, says Bernita, "Stacey would have been a crib death."

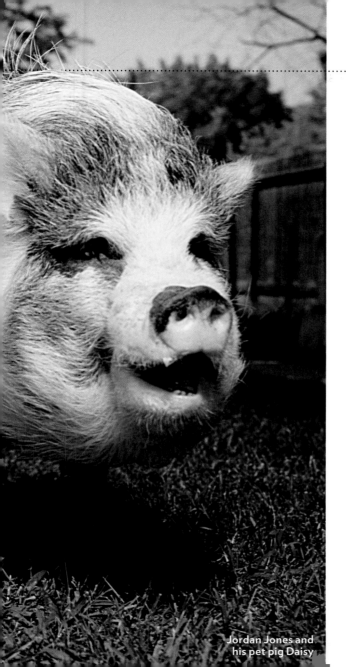

Jordan Jones and his pet pig Daisy

A BRAVE PIG TAKES ON A RAGING PIT BULL

Jordan Jones, 7, was playing in his front yard when he noticed an angry pit bull charging straight at him. Luckily Jordan had a bodyguard: his 150-lb. potbellied pig Daisy. The pig rushed into the pit bull's path, and the dog—a neighbor's pet that had escaped its enclosure—clamped onto her head. "There was so much blood spraying," said Jordan's mom, Kim Jones, who heard the squeals and ran outside. "It killed me to see Daisy hurt, but if not for her it's possible my son wouldn't be here today." Jones screamed for her husband, who brought out his handgun. After asking permission from their neighbor, who had also raced outside, he killed the dog.

A vet was called, but, lacking a special anesthetic needed for pigs, he had to improvise. He gave Daisy two cans of beer to numb the pain while he tended to her wounds. Daisy was back to her hammy self a few weeks after the October 2004 attack.

You are the Sunshine of my life: J.W. Erb and his heroic bird.

A QUICK-DRAW MACAW
TAKES A BITE OUT OF CRIME

Michael L. Deeter didn't know what he was in for when he broke into J.W. Erb's Williamsport, Pa., apartment in 2006. Sure, he got away with a camcorder and $100, but he also sustained some nasty bites, thanks to Sunshine, Erb's blue-and-gold hybrid macaw. "The police said he looked like somebody rolled him in barbed wire," said Erb. Which is why they were able to catch him so quickly. Turns out Deeter was being held on an unrelated charge the same day and was already in jail when Erb called 911. Confronted with pictures of Sunshine, Deeter confessed. Sadly, Sunshine didn't escape the scuffle unscathed. When Erb first walked into his home, he found the bird "curled up in a laundry basket. My heart sank. He was missing a lot of feathers, and there was blood all over the apartment." Sunshine, however, was not a parrot without pluck: Soon he picked himself up and was back to singing Cher songs and dancing in the shower.

COLD COMFORT

Even with the temperature hovering at 35° below zero, dog trainer Jim Gilchrist of Innisfil, Ont., decided to take his two pets—Tara, a rottweiler, and Tiree, a golden retriever—out for their usual afternoon walk on Feb. 24, 1995. After passing through the woods, they headed home across frozen Lake Simcoe. But as the dogs bounded ahead, Gilchrist, 61, felt the ice give way. "I was walking along, and it went 'pop' right through," he recalled. "It happened so fast. I thought, 'This could be the end.'"

Hearing her master's cries, Tara raced over, only to crash through herself. As they thrashed about, Tiree appeared. "All I could think was that she'd meet our same fate," said Gilchrist. Instead the whining dog crouched on her belly and crawled to the hole. As Gilchrist grabbed Tiree's collar, Tara scrambled atop his back to jump out. Then she lay on her belly alongside Tiree so Gilchrist could grab her collar with his other hand. While the 200-lb. Gilchrist hung on, the dogs clawed backward until he was safe. "They had every right to run ashore," said Gilchrist, who, back home, gave his dogs a hot bath. "They risked their lives to save me."

Having since won several awards for heroism, Tiree remained her happy-go-lucky self but Tara became "paranoid about water," said Gilchrist. Of course, he did too. "I will never go out on the lake when it's frozen—or let my animals."

NIKITA TAKES A BULLET

In 1998 John Schonefeld was walking his chow-shepherd mix Nikita at 1:30 a.m. when an armed man in a red ski cap jumped out of a car and lunged at him. Then Schonefeld heard the roar of gunfire. When he opened his eyes, he found he was still alive—thanks to Nikita, who had jumped in front of the gun just as the stranger (who was arrested two days later) pulled the trigger. "She took a bullet for me," said Schonefeld. "A lot of people wouldn't do that, but my dog did." The bullet had ricocheted off the dog's skull; Nikita spent six hours in surgery. Recalled Schonefeld: "[My dad] said, 'I don't care what it costs, you make sure that dog doesn't die.'" Back home, Nikita's meals improved, from kibble to sirloin steak. "Every time I feed her," said Schonefeld, "I remember what she did for me."

DID THIS CAT DIAL 911?

When Officer Patrick Daugherty, prompted by a 911 call, walked into Gary Rosheisen's Columbus, Ohio, home, he thought nothing of the orange tabby sitting next to the phone in the living room. Then he realized that the cat's disabled owner had collapsed on his bedroom floor—with no phone within reach. Could the cat, Tommy, have made the call? Was that why the 911 dispatcher heard nothing on the line? "We were both scratching our heads," said Rosheisen, who had fallen while getting out of his motorized wheelchair. Of course, it's possible the cat just got lucky batting the speed dial and the speakerphone. But Rosheisen noted that, after adopting Tommy in 2002, he had tried to teach the cat to call 911 with its paws but later stopped after worrying that the cat might make random calls in hopes of getting a treat. Still, somehow a 911 call was made. "All I can say is, it was a miracle," said Rosheisen.

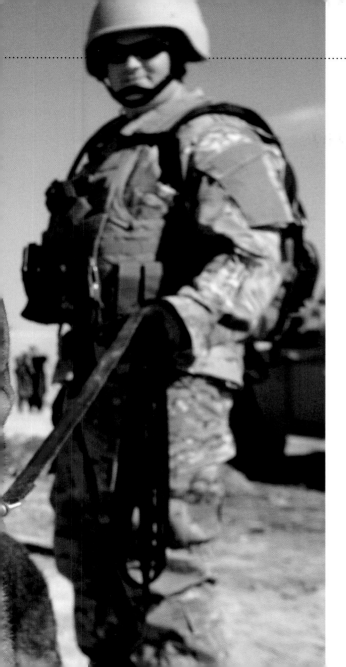

HEALING THE
DOGS OF WAR

The only facility of its kind, the Holland Military Working Dog Hospital, at Lackland Air Force Base in San Antonio, Texas, treats the canines who serve our country. It's "the Walter Reed for dogs," says director Col. Bob Vogelsang of the hospital, named for Lt. Col. Daniel E. Holland, a veterinarian killed in Iraq in 2006. "I'm not dissing veterinary equipment, but we have excellent human equipment"— including CAT scans, surgical suites and an ICU that is more *ER* than *Dr. Dolittle*.

Most dogs, who might be treated for everything from wounds to post-traumatic stress, return to duty, just as soldiers do multiple tours; those that don't are adopted. "Once they can't do their job, we want them to live out their years chasing squirrels and getting loved," says Vogelsang.

Jennifer Cox flew all the way from Duncannon, Pa., to adopt Fritz, a 12-year-old German Shepherd, in 2009. His only quirk? "When UPS came," she said, "he jumped into the truck and sniffed the packages—they were safe!" Even in retirement, Fritz was doing his duty; semper Fido. "Someone's son came home because of a dog," she said. "He was perfect."

HERO PETS

The base also breeds puppies.

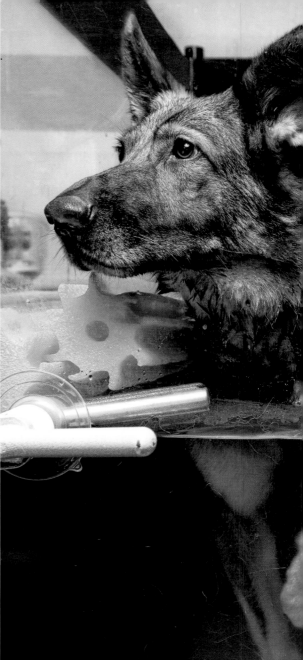

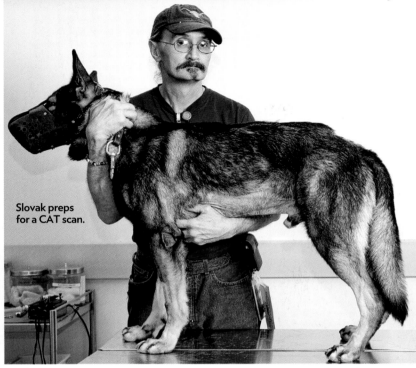

Slovak preps for a CAT scan.

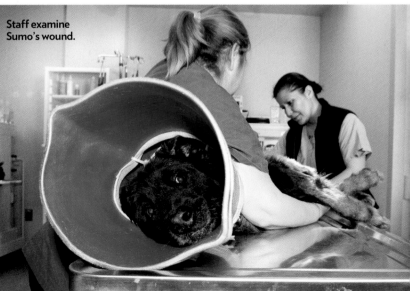

Staff examine Sumo's wound.

WATER WORKOUT

Aika rebuilds muscle on a submerged treadmill. "Water is a great therapy tool," says technician Kelley Meyer.

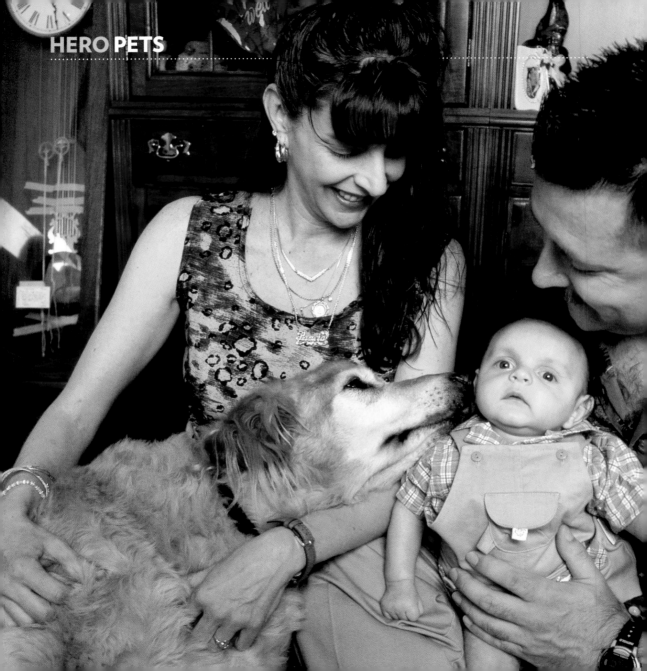

BULLET BARKS AND
SAVES A BABY

Pam and Troy Sica had to borrow the $4,000 it cost to remove a tumor from their beloved 13-year-old golden retriever Bullet in 1999. Talk about a bargain. Three years later Pam was heating a bottle for the couple's 3-week-old son, also named Troy, at the family's Bellport, N.Y., home when Bullet appeared in the kitchen doorway, "barking, running halfway down the hallway, then coming back," said Pam. "I realized something had to be wrong." Racing to the bedroom, she found the baby "with his head back, gurgling or choking." Rushed to the hospital, Troy was diagnosed with double pneumonia. "If I didn't have Bullet, my baby wouldn't be alive," said Pam. When young Troy returned, Bullet seldom left his side. The dog's heroism, said the elder Troy, "was more than just instinct. It was his heart."

THE CAT WHO CAME IN FROM THE COLD REPAYS A KINDNESS

When a stray cat began hanging out on the deck at Daniele and Dan Kates's house in Lisbon Falls, Maine, the couple didn't want it sticking around. Daniele was allergic, and Dan had never liked cats. Still, one cold October night, the couple couldn't help feeling sorry for the feline and brought her in.

The tabby they named Muffin soon repaid their kindness. On Jan. 12, 1999, Daniele was making lunch for her then-4-year-old twins Jordan and Benjamin when she heard Muffin crying and pawing the upstairs master bedroom door. Daniele discovered the room engulfed in smoke and flames shooting out of the closet. All escaped unharmed, and news of Muffin's heroism spread; in March 1999 she was named Cat of the Year by a division of the International Cat Association. Even Dan warmed to her. "When Muffin's on the counter," said Daniele, "he never yells at her to get down." As a result, she admitted, "she's kind of spoiled."

RUCKUS RABBIT TO THE RESCUE!

Ed and Darcy Murphy bought a rabbit—a gift for their kids Callie, 10, and Dylan, 8—at a garage sale and didn't think much more about it. Days later Robin—as the bunny had been named—started bouncing frantically in her cage at 3 a.m., waking Ed. While up, he noticed Darcy, 31, who had gestational diabetes, was making "raspy, snoring" noises, but he thought nothing of it and tried to get back to sleep. But Robin wouldn't stop her ruckus. That's when Ed checked again and noticed that Darcy was barely breathing. He called 911; the paramedics said Darcy had gone into insulin shock. "If Robin hadn't made all that noise, the baby and I would have died," says Darcy, who gave birth to a healthy girl, Brenna, a month later. Is there an explanation for Robin's antics? "With diabetes, it's likely Darcy was giving out significant ketone odors that the rabbit was reacting to," said Dr. Bonnie Beaver, an animal behaviorist. Or, as Ed puts it, "She knew something I didn't."

MY HERO, **ROCKY**

If there was ever a dog who stopped a nightmare, it's Rocky. In 1998, as Joan and Mike Staples and their three children slept, a convicted sex offender broke into their house in Harboro, Pa. Going into 8-year-old Laura's bedroom, he clamped his hand over her mouth and carried the struggling child downstairs. That's where he encountered Rocky, a 116-lb. Rhodesian ridgeback, who went at him teeth first. He dropped Laura and fled.

The intruder, Frankie Burton, was soon nabbed by police in a nearby park. "He didn't resist much; he was pretty beaten up," said Mike. Burton is now serving a term of 42 to 118 years in prison. "It's horrible to imagine how different our lives would be if he had gotten out the door with Laura," said Joan. "Without Rocky, I don't know if we'd even have her alive."

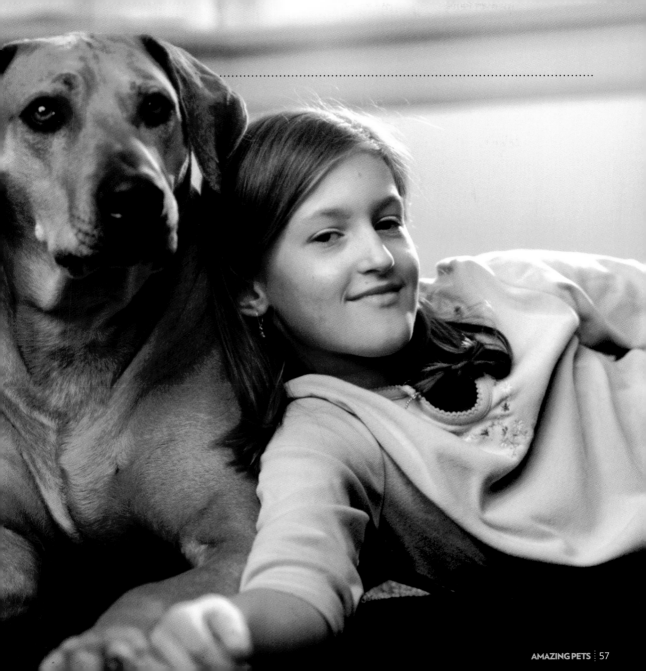

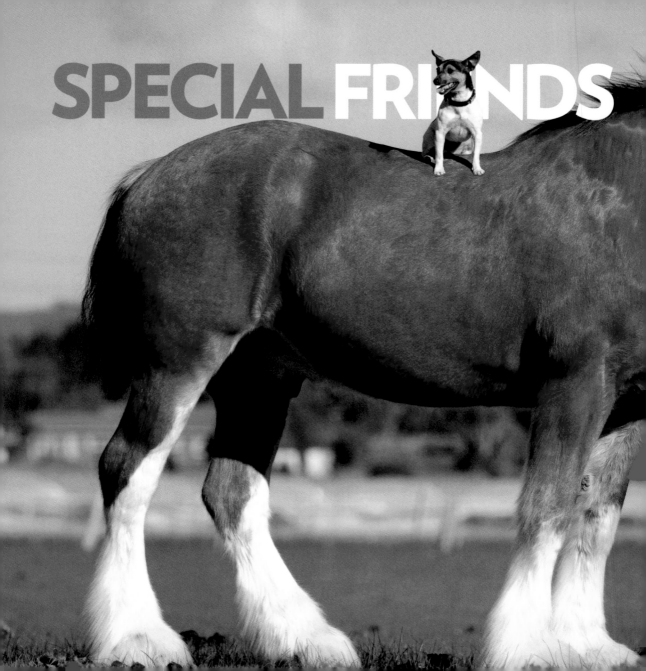

SPECIAL FRIENDS

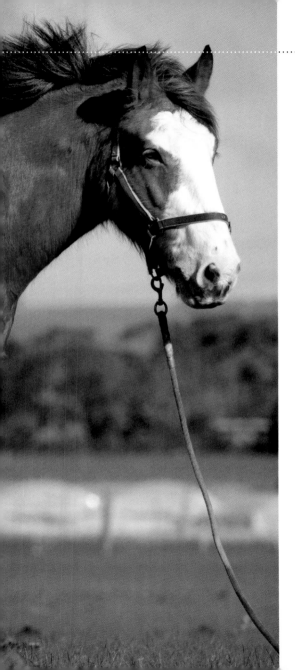

Yea, and the lion shall lay down with the lamb. Also, it turns out, the dog shall frolic with the elephant, the cat dine with the bear, and the orangutan swim with the bluetick hound

BACK IN THE SADDLE AGAIN

Even best friends can, inadvertently, hurt one another. Who hasn't regretted a thoughtless remark, say, or forgotten a thank-you note? For Berry the Chihuahua and Leroy the Clydesdale, best buds who live near Melbourne, Australia, the faux pas came when Leroy, who weighs about a ton, accidentally stepped on Berry's head. A vet gave her less than a day to live, and offered to put her down. Instead, owner Abbey Newton took Berry home, where, a day later, she was up and around, and back scampering with Leroy—from, one presumes, a safer distance.

BELLA AND TARRA FOREVER

Elephants are social animals, but they usually hang with other pachyderms. At the Elephant Sanctuary in Hohenwald, Tenn., Tarra, an 8,500-lb. female, became BFFs with Bella, a 35-lb. mutt who wandered onto the property. The two rambled together happily for nearly a decade (check the Web for remarkable video).

In 2007, when Bella was injured, Tarra kept vigil outside the Sanctuary's clinic for two weeks until her friend recovered (then petted Bella gently with her trunk). Sadly, Bella was killed by coyotes in 2011. Based on the physical evidence, Steve Smith, the Sanctuary's director of animal husbandry, believes that Tarra found Bella and carried her back to the area where they used to play together.

THE SWIM TEAM

The first time Roscoe the bluetick hound met Suryia, a 7-year-old orangutan at the T.I.G.E.R.S. preserve in Myrtle Beach, S.C., he "ran up to Suryia and they jumped into each others arms," says Bhagavan Antle, the preserve's director. So began a beautiful friendship. The pair's favorite pastime? A daily dip in the pool.

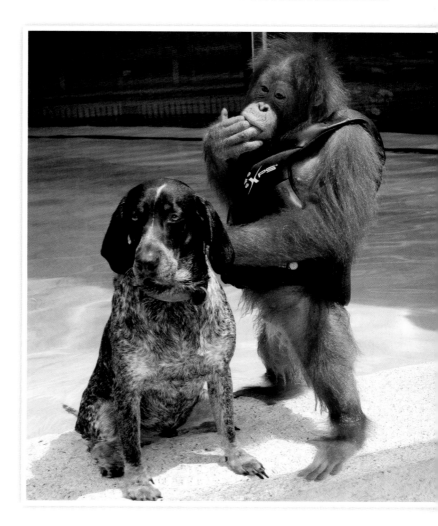

PAT THE BUNNY

When Samantha the gorilla's longtime companion Rudy died in 2005, zookeepers tried to comfort her with a stuffed toy gorilla, which she "carried around everywhere," says Scott Mitchell, CEO of the Erie, Pa., zoo. Still, her caretakers felt she needed a living companion. At 47, she was too old for a young male to be brought in, and she'd had trouble bonding with others of her kind. So they got her a…bunny? Yep; Samantha was introduced to Panda, a 6-month-old Dutch rabbit, and after some supervised visits the hopper moved in permanently. Today "the stuffed animal is not the most important person in her life," says Mitchell. "Panda is."

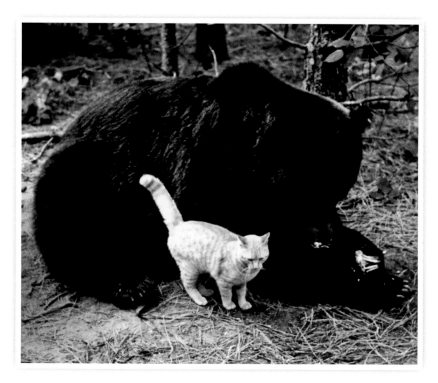

MEOW MIXER

Usually, when a bear has a cat for lunch, it's very bad news for the cat. That wasn't true, however, at an animal rehab center in Grants Pass, Ore., when an orange kitten—later named Cat—slipped into an enclosure that was home to Griz the grizzly bear. Some feared Cat would become Snack. Instead, Griz offered him a piece of chicken, and the two became fast friends.

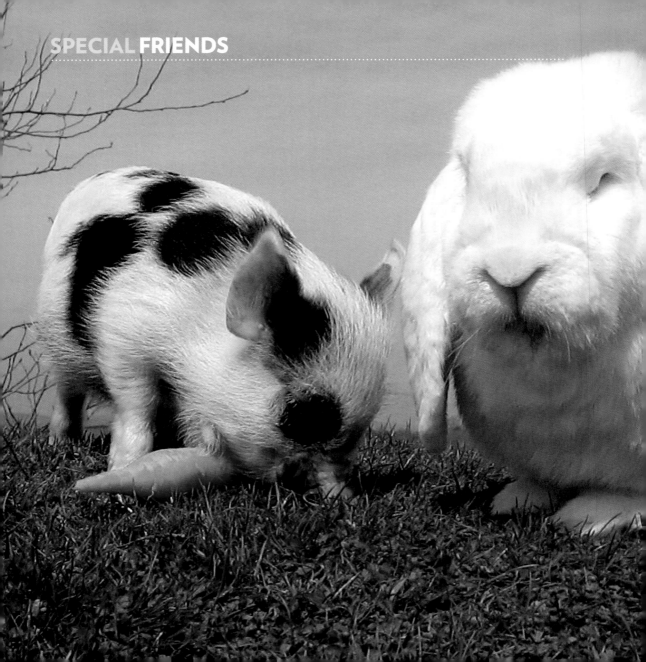

DUDE!
THAT'S MY
CARROT!

William, a piglet, began hanging out with Charles, a rabbit, at Pennywell Farm in Devon, England. Come snack time, however, Charles often wound up with the shorter end of the stick.

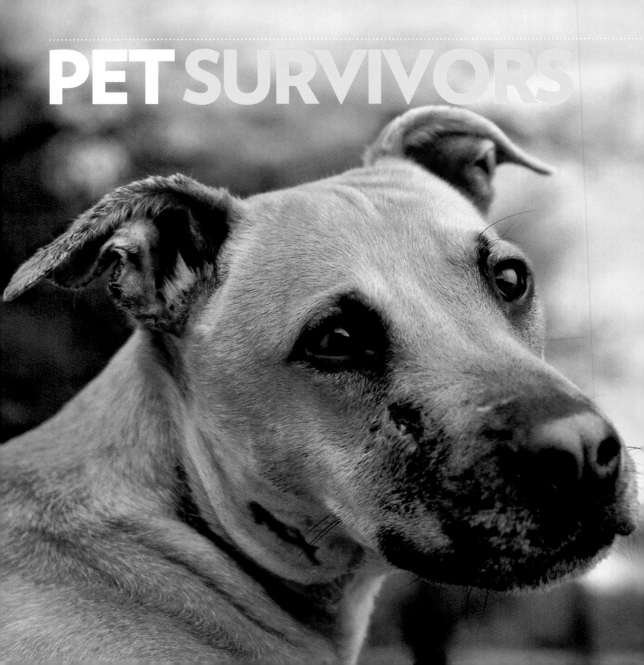

PET SURVIVORS

*Courage? Ingenuity? Will? Love? Something
kept these remarkable animals alive despite fire,
ice, a tornado and even a bullet*

DOSHA
THE WONDER DOG

Every dog has its day. For Dosha, a 10-month-old pit bull mix, April 15, 2003, was emphatically, definitely, positively not it. That morning her owner, Louetta Mallard of Clearlake, Calif., let her out in the yard. Bored, Dosha leapt over a 4-foot cyclone fence—and was promptly hit by a fast-moving pickup truck. "She wasn't moving and was glassy-eyed," said a witness. "I said to myself, 'That's a dead dog.'"

A police officer arrived on the the scene and, to end any possible suffering, shot Dosha in the head.

Dosha was taken to the local animal control center and placed in a freezer for corpses awaiting disposal. Two hours later, a worker opened the freezer and found Dosha sitting up—dazed, no doubt confused, and, perhaps, more than a little teed off. Still, while recovering at a local veterinary clinic, she licked visitors' hands.

"That dog had everything go wrong, but someone was looking out for her," said an animal control official. "This was her lucky day."

TOUGHER THAN
A TORNADO

Sucked from a garage by a tornado in 2011, Mason, a 2-year-old terrier mix, spent three weeks crawling home on legs so fractured that "one of his bones was nearly ready to come through his skin," said his vet Dr. William D. Lamb. Mason's owners—an Alabama family who wished to remain anonymous—woke one morning to find the severely injured dog (dehydrated and, at 14 lbs., barely half his normal weight) had somehow climbed onto their battered front porch. Amazed by Mason's resilience, Lamb and others donated their services, inserting 17 pins in Mason's legs and providing any comfort they could. When Mason's family visited him in rehab, said a caretaker, "his whole body wiggled when he saw their little girl." Said another: "I've seen dogs who have endured unbelievable cruelty and hardships but I've never seen one who was that injured yet remained so happy and sweet."

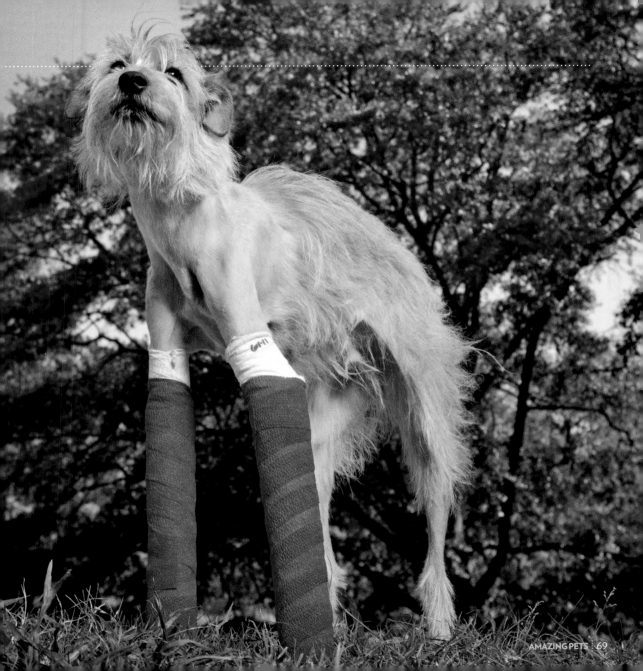

SEA WOOF

For a spell there, it looked like Hokget, a terrier mix whose name means "good fortune" in Taiwanese dialect, was having trouble living up to her moniker. First, the engine room of the *Insiko 1907*—the tanker on which her owner, Chung Chin-po, was captain—caught fire. Luckily a passing cruise ship saved the crew. Unluckily Chin-Po, thinking he wasn't allowed to bring Hokget, left her behind. Luckily, passengers on the cruise ship heard a dog bark, and alerted the Hawaiian Humane Society, who sent out a search party. Unluckily, they couldn't find the *Insiko 1907*. Very luckily, Hokget was resourceful and figured out how to catch rats and lap up rainwater from squalls.

Then, 24 days after the fire and 680 miles southwest of Honolulu, a U.S. Coast Guard C-130 pilot spotted the *Insiko*—and something more. "Suddenly a ball of fluff dashed from one side of the bridge to the other," said the pilot. "She was alive." Brought back to Hawaii, Hokget gave up the sailing life and moved in with a friend of Chin-po, never more to roam.

ALOHA SPIRIT
Feral and snarling when rescued from the fire-ravaged *Insiko* (above, in port), Hokget (far left, in lei) mellowed by the time she arrived in Honolulu.

CANINE CASTAWAY

Boating near Australia's Great Barrier Reef with their dog Sophie Tucker, Jan and David Griffith hit rough weather. While struggling with the helm, says Jan, "We took our eyes off Sophie for a moment, and she was gone." They came back for two days to search, but then, heartbroken, accepted that Sophie was lost.

Indeed she was, but not permanently. Four months later, rangers found her on St. Bees, a rarely visited island. She had swum more than five miles, then learned to hunt crabs and lizards for food. Reunited with the Griffiths, she "bowled us over," says Jan—then slipped seamlessly into her old domestic routine.

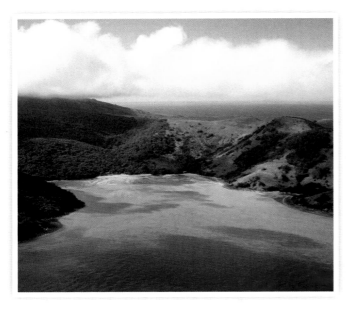

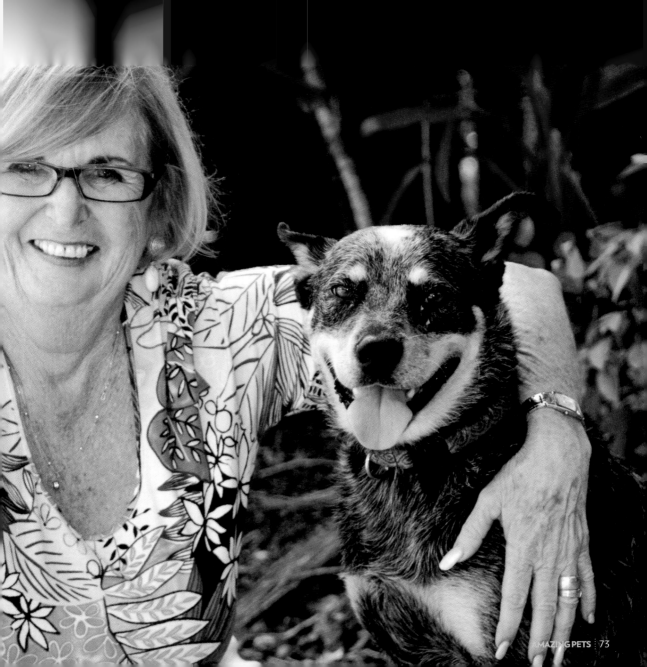

LOVE & MONEY

Paying six figures for a cloned puppy? Turning down $100,000 in a divorce in order to keep the pets? Leaving your Maltese $12 million? Sometimes, swag comes second to a tail that wags

Edgar and Nina Otto of Boca Raton, Fla., loved their Labrador, Lancelot, and were devastated when he died of skin cancer in 2008. Luckily the Ottos had the foresight to freeze Lancelot's DNA before he became ill. They also had the funds—Edgar is the son of NASCAR cofounder Edward Otto—to buy a $155,000 cloned copy of their dog. To create Lancey, as the new pup was named, Korean scientists placed Lancelot's DNA in another dog's egg, from which the genetic code had been removed, then placed the altered egg in a female dog to incubate. Amazing science, maybe, but $155,000 for a pet? That amount "could feed, house, spay and neuter 4,000 animals," noted one animal rescue official. The Ottos countered that they give plenty to charity, including more than $330,000 to the Tri County Humane Society. And they refused to put a price on joy. "I feel like this is our first dog," said Nina. "We are thrilled."

The
$155,000
CLONED PUPPY!

DOLLY,
IS THAT EWE?

Scotsman Ian Wilmut and his team rocked the worlds of biology and ethics in 1997 when they introduced Dolly the lamb (below, in close-up; and at right in a tricked-up photo), the first mammal ever cloned from an adult animal. "It shatters what we thought was true about biology," noted one admiring professor. Called brilliant, Wilmut modestly demurred. "Genius, no," he said. "Persistent, yes."

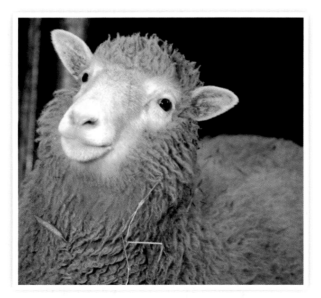

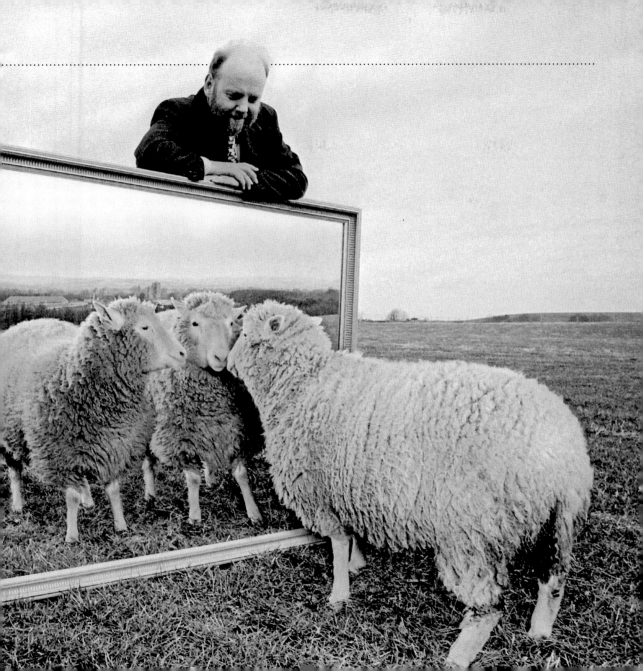

A $125,000 CANINE
CUSTODY BATTLE

After she split with her banker fiancé in 2007 and moved from New Jersey to Denver, "I grabbed the dogs," said newswoman Peggy Bunker. That set off a two-year custody battle over West Highland terriers Barkley and Willis, with Bunker paying $25,000 in legal fees, making 23 trips to New Jersey and even turning down a $100,000 offer from her ex to walk away. A New Jersey judge, deciding Bunker had been their primary owner, eventually awarded her custody. "He was good to the dogs," she said of her ex. "But that doesn't make them his."

COPIED CAT!

He looked like an ordinary kitten, and that's what was extraordinary: CC—short for Carbon Copy—born Dec. 22, 2001, made headlines as the world's first cloned cat. Researchers at Texas A&M University oversaw the project, which was funded by Genetic Savings & Clone, a company that hoped to go into the pet-cloning business. Alas, although at least one woman paid $50,000 to have her cat cloned, Genetic never found enough cash-rich customers willing to pay that price and closed in 2006.

CLAW AND ORDER

When Lynn Goldstein and her husband, Tom Nichols, divorced in 2000, a judge ordered them to divvy up their pets. Nichols got cats Beanie and Kasey, and Goldstein took Bobo the rabbit and three dogs. But Goldstein balked because she felt Nichols's schedule—he worked as a UPS pilot—would keep him from caring for the cats properly. Nichols went to court, where a judge—who had already issued seven orders concerning the cats—went ballistic when he saw video, made by a private detective, of Goldstein hiding the cats before coming to court. "Extreme…contempt of court," said the judge, who gave her 30 days.

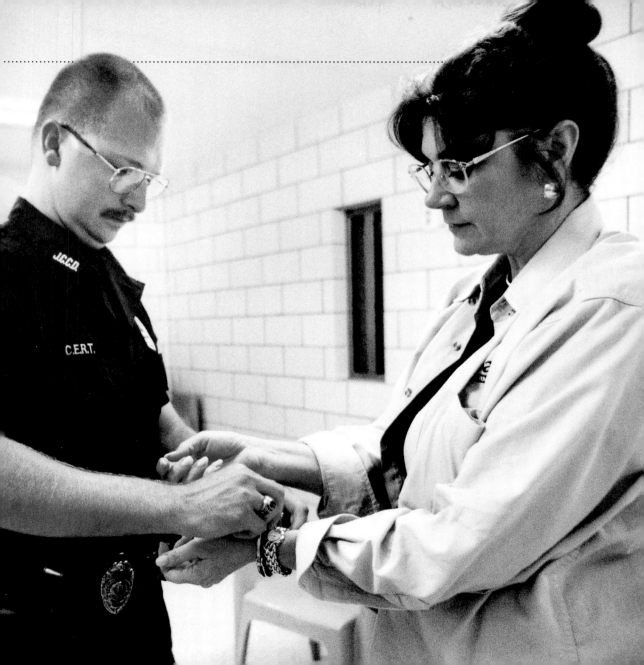

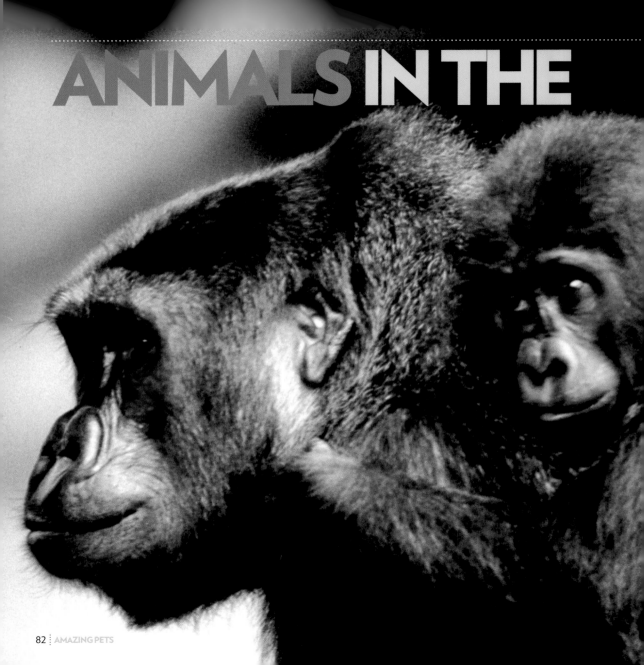

ANIMALS IN THE

NEWS

Kleptomaniac cats! The world's smallest police dog! Sweaters for chilly penguins! Curious, quirky and heroic animals make headlines around the globe

GORILLA WITH A HEART O'GOLD

Binta-Jua, a lowland gorilla at Illinois' Brookfield Zoo, had always been "a people oriented gorilla," said keep Craig Demitros. But no one suspected how truly special Binta-Jua was until a startling moment in August 1996, when a 3-year-old boy somehow scaled a barrier and fell into the zoo's gorilla enclosure. As visitors watched in panic, Binta-Jua approached the unconscious boy (whose name was never released to the press), gently scooped him in her arms and, growling to warn off the advance of at least one other gorilla, carried him to a maintenance door, where workers where able retrieve him and get him to a hospital. It's possible that Binta-Jua, who had been taught to bring her own offspring to handlers for medical checkups, was simply repeating that behavior. On the other hand, in 1986, Jambo, a male gorilla at a British zoo who had never had such training, did much the same thing, protecting a boy who had fallen into his enclosure until zoo personnel could get the child to safety.

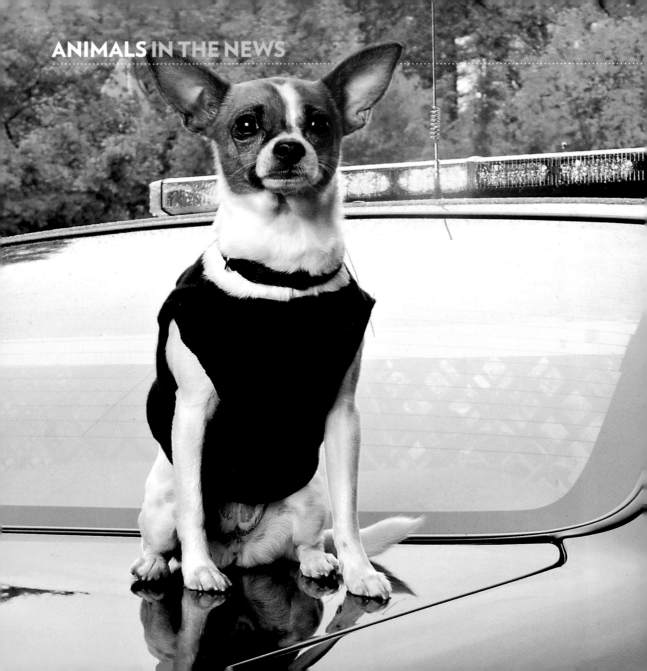

DEPUTY DOG

Eight pounds of canine cop, Midge, a drug-sniffing Chihuahua–rat terrier mix on the force in Ohio's rural Geauga County, made it into the *Guinness World Records* as the world's smallest police dog. Ah, the burdens of celebrity: "She receives mail and gifts from around the world," said Sheriff Dan McClelland. "The governor asks about her all the time."

SEAL OF APPROVAL

Annette Swoffer of Welcome Bay, New Zealand, discovered a wild seal pup—who had apparently entered through a cat door—asleep on her couch.

KLEPTO CAT?

When his British owners had a baby, Cwtch, a Siamese, began stealing stuffed animals from neighbors' homes. An animal psychologist suggested Cwtch was, from his perspective, hunting and sharing with her family.

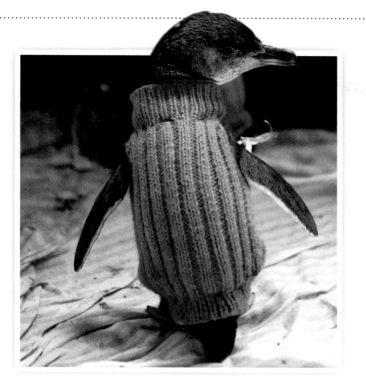

MINI PURL

When penguins at Australia's Phillip Island Nature Park—
famously sharp dressers, most often seen in tuxedos—
get oil on their feathers from local spills, leaving them vulnerable
to cold and toxins, Linda Parker and her pals knit tiny sweaters
for the birds to wear in rehab. Parker refuses to mechanize
the process. "I'd like to think a penguin would prefer a handmade
sweater," she says. "If I were a penguin, I certainly would."

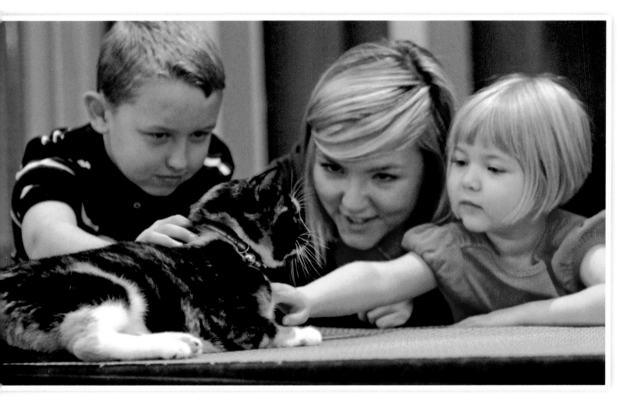

WANDERING WILLOW

Willow the cat walked out of her Colorado home in 2006 and, in 2011, was found 1,800 miles away in New York City. A good Samaritan brought her to an animal shelter, where a scan of a microchip revealed her identity. Said her delighted, reunited owner, "If I could microchip my kids, I would."

BEAGLE MANIA!

Y ou say you want an evolution?
Giving cause for pause, Daisy the
contrarian canine—who wouldn't use her
hind feet whenever owner Brenda Leonard
of Portland, Ore., put little shoes on them—
did the two-step and shook her booties.

'YOU BE GOOD'

An African gray parrot with a vocabulary of more than 100 words, Alex "revolutionized the way we think about bird brains," psychologist Diana Reiss told *The New York Times*. "That used to be a pejorative, but now we look at those brains—at Alex's—with some awe." His last words, to friend and trainer Dr. Irene Pepperberg, the night before he died, at 31, of natural causes? "You be good; see you tomorrow. I love you."

FOR WHOM THE CAT PURRS

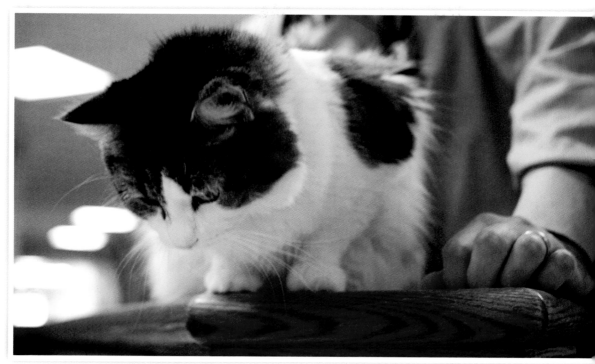

In a 2007 *New England Journal of Medicine* article, Dr. David Dosa described how, in more than two dozen instances, Oscar, a cat who lived in a Providence, R.I., nursing home, leapt onto the beds of patients and nuzzled them hours before they died. Staff speculated that Oscar's behavior might have been triggered, somehow, by his sense of smell, or that he may have been responding to the low lighting and soft music that were part of the home's final stages of care.

IT'S A DOG-EAT-(TOY) DOG WORLD

Alfie, a spaniel living in Cheshire, England, was looking a little wan, so his owner took him to the vet, who quickly discovered the problem: Peering out from an X-ray of Alfie's stomach was a tiny, perfect, smiling pooch, actually a dollhouse toy the spaniel had swallowed. After two hours of surgery both dogs were fine.

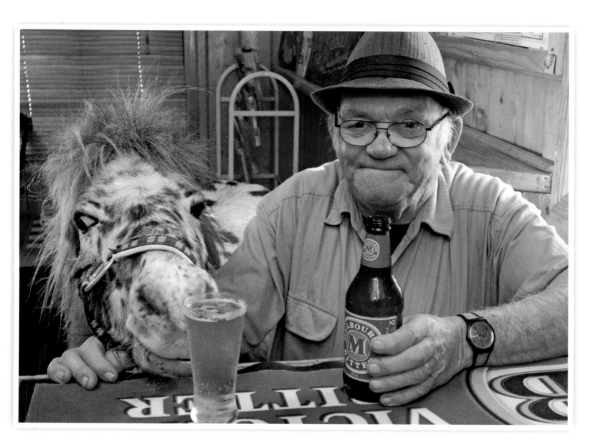

PONY UP

Henry, a pint-size Appaloosa, likes a pint every Sunday at the Logan pub near St. Arnaud, Australia.

PAPA'S
SIX-TOED CATS

The fur flew in Key West, Fla., in 2007 when the USDA insisted that the Ernest Hemingway Museum's famous six-toed cats—nearly four dozen in number, who wander the grounds and are believed to be descendents of the writer's six-toed feline Snowball— be caged for their safety. Years later the situation is still not completely resolved.

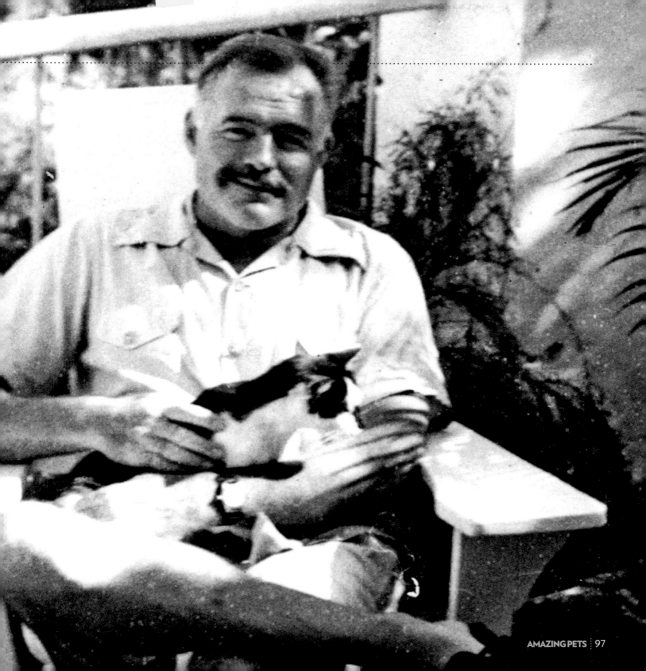

CAUGHT
ON CAT CAM

Like many pet owners, Deirdre and Michael Cross wondered what their cat, Cooper, did while prowling their Seattle neighborhood. So they attached a tiny digital camera, set to shoot every two minutes. "We were blown away," says Michael. "The colors are so brilliant," adds Deidre. "And the angles!" Art—or is it cat?—lovers agreed: At a gallery show, the couple sold more than 20 prints at $275 each. The photographer, alas, did not attend. Why? Says Deidre: "Because he's a cat." (More at photographercat.com.)

MAKING WAVES

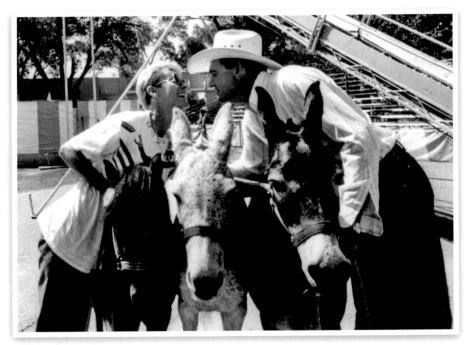

In 1991, Tim and Patty Rivers drew crowds (here at the New Mexico State Fair) and protest with an act called The World's Only High Diving Mules, in which Smokey, Daisy and Kip would ascend to an 18-ft.-high platform and plunge into a 6-ft.-deep pool. For that they got a carrot. Tim Rivers denied there was any cruelty. "This," he claimed, "has to be one of the safest things done with animals."

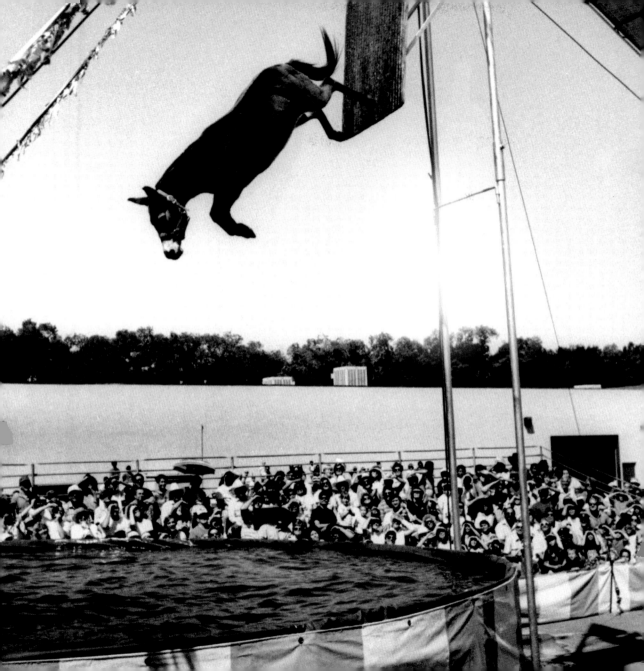

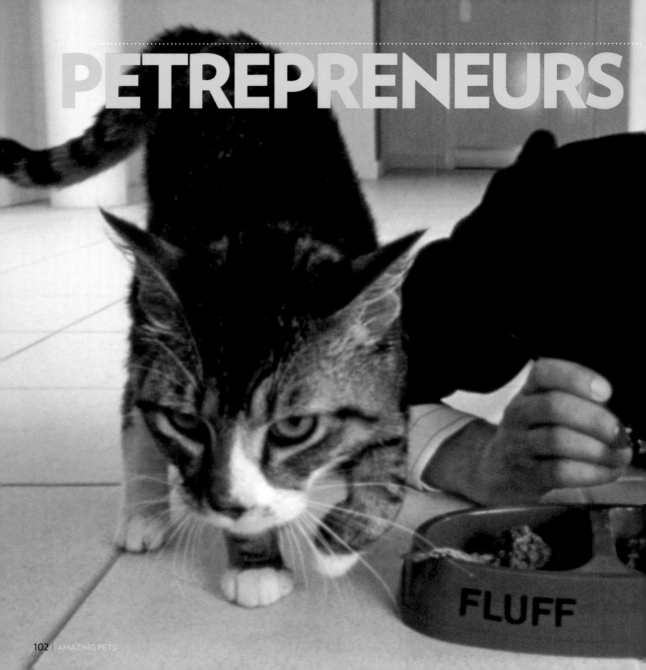

PETREPRENEURS

FLUFF

From test-tasting cat chow to translating your dog's bark: Somewhere, someone is thinking about your, and your pet's, every conceivable need

MAN BITES DOG FOOD

Working under the simple dogma that no product should reach shelves without passing his lips, Englishman Edwin Rose, a food taster for a large supermarket chain, tested even pet food. After sampling more than 300 types—including, for example, Prime Cuts Tripe Mix—and backed by sales figures, he determined that pets don't like their food cold; prefer organ meats to prime cuts; and don't like their meals served in one big glop. His wife, Paulette, an ex-model, did complain about one side effect of Edwin's work: "I've bought him countless mouthwashes and toothpastes," she says, "but it doesn't get rid of that meat smell."

MOOS YOU CAN USE

Dogs, cats and hamsters are wonderful animals, but they have one defect: You can't lie down on them. Or at least you shouldn't. With that in mind, cow lover Helga Tacreiter created the Cowch, a life-sized, cow-like, pasture-pedic pillow.

MUST-SEE TV, IF YOU'RE A CAT

Figuring the feline demographic already spent a *lot* of time on the couch, the Oxygen channel tested a half-hour show, *Meow TV*, in 2003. One popular segment: "Squirrel Alert."

HAIR OF THE DOG

Does your Shar-Pei look sharper than you do? Does your setter look better than your best sweater? Who's groovier, you or your Bouvier? For those who dread being in fashion's doghouse, authors Kendall Crolius and Anne Montgomery offered a novel solution: *Knitting with Dog Hair*, subtitled *A Woof-to-Warp Guide to Making Hats, Sweaters, Mittens & Much More*. Better the "dog you know," said Crolius of using fibers from Fido, "than a sheep you never met."

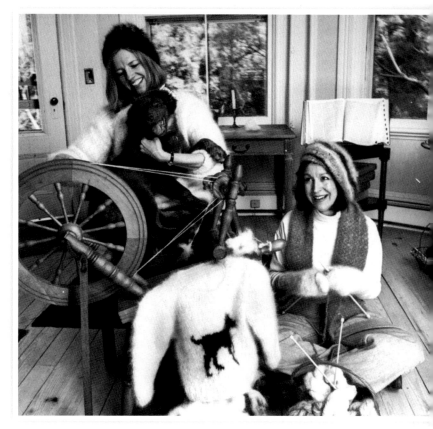

EEK-NESS, NOT PREAKNESS

Conducting mouse races for charity, Harvey Coffee (left) and partner Bob Dobbins raised more than $100,000 in three years.

BOWWOW HOUSE

"**M**y fascination with poodles can't be intellectualized," said curator Doren Garcia of his L.A. poodle museum. "It's an emotional thing."

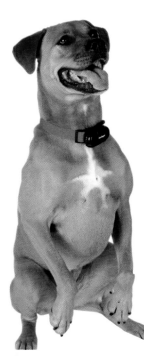

‹ RUFF TRANSLATION

A Japanese invention, the Bow-Lingual purports to translate your dog's barks into phrases like "How exciting!" and "I feel like dancin'!"

PETREPRENEURS

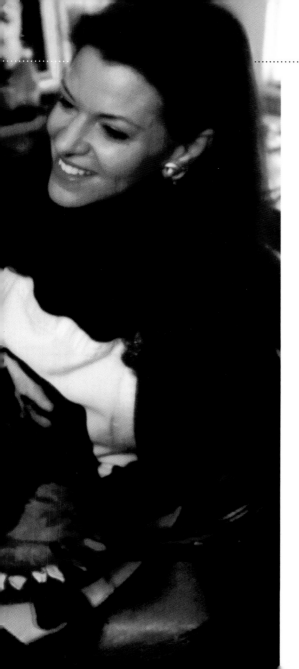

PUP GOES THE EASEL

They don't beg or roll over, but dogs of the rich and famous often sit, at least briefly, for painter Christine Merrill, perhaps America's preeminent canine portraitist. "She works in the 18th-century tradition with colors and techniques, and at the same time, she really understands animals and is able to paint character," said a Manhattan gallery owner. One of her clients, Oprah Winfrey, whose cocker spaniel Sophie sat for Merrill, certainly agreed. "There's a sweet sadness in Sophie's eyes that Christine was able to capture," said Winfrey. "It's her masterpiece."

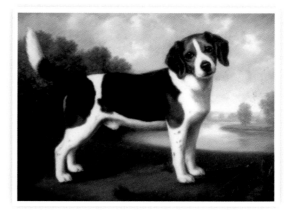

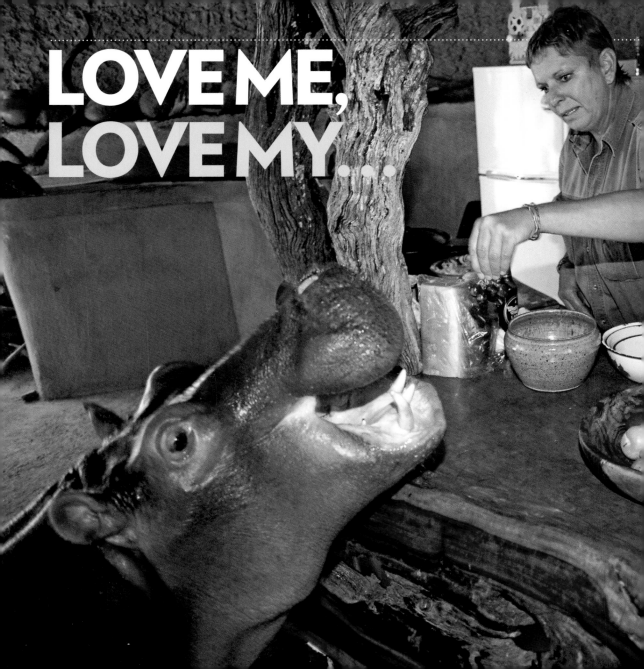

LOVE ME, LOVE MY...

Cats? Schmats! Gimme a gator any day.
For some animal lovers, only the exotic will do

HIPPO!

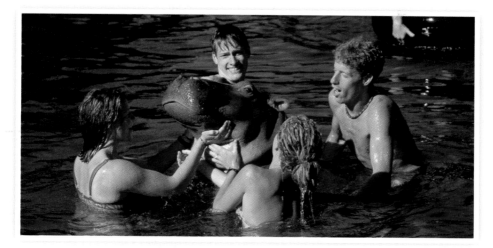

It started simply enough: Tonie and Shirley Joubert found an abandoned baby hippo near their South African farm and, smitten, took her home. Both the hippo, whom they named Jessica, and their love grew almost exponentially—despite obvious problems. For starters, "Jessica doesn't have good toilet manners," noted Tonie, a former game warden. "She makes a mess everywhere." Also, "when she eats onions, her burps are horrendous." And, says Shirley, "my hands and clothes are always sticky from drooling saliva." So what's the attraction? "When I ask her for a kiss," says Tonie, "she puts her head up, she wags her tail and she is happy." Since PEOPLE first wrote about her in 2003, Jessica—now weighing in at nearly one ton—has appeared on the *National Geographic* channel and on Animal Planet and TV shows around the world. Although she now lives with wild hippos, she remains very attached to the Jouberts and visits every day. She is, the couple notes on jessicahippo.com, "the most wonderful precious thing."

LOVE ME, LOVE MY . . .

COYOTE!
Writer Shreve Stockton blogs about life with her coyote Charlie, who coexists happily with her dog, cow and horse.

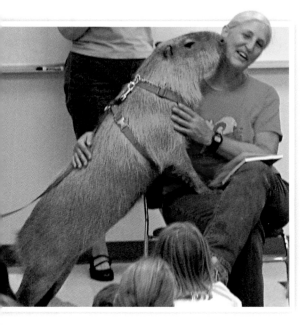

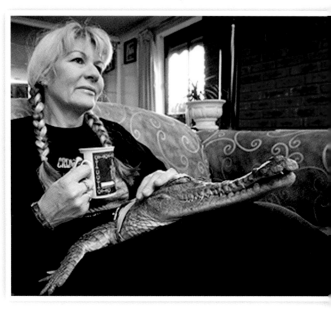

CAPYBARA!

"He's very needy," says Texan Melanie Typaldos of her 100-lb. rodent (the largest such species on Earth), "but I love him to death! He loves to lick my face." And, yes, he's housebroken.

CROCODILE!

Australian Vicki Lowing cuddles with her 5-ft. croc, Johnie, and walks him on a leash. When her husband gave her an ultimatum—"him or me"—she chose Johnie. "Husbands," she says, "can look after themselves."

ANIMAL ATTACK!

Encounters of the most frightening kind—
and living to tell a riveting tale

LIONHEART

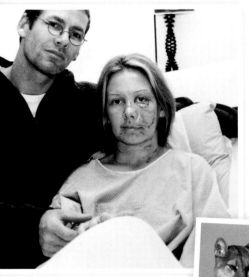

Hjelle with her husband,
James Poindexter,
after the attack.

O ut of my peripheral vision I saw a flash of reddish-brown fur over my right shoulder," said Anne Hjelle, who was mountain biking in a wilderness area near Mission Viejo, Calif. "I knew instantly it was a mountain lion. He latched on with his jaws to the back of my neck." As her riding pal Debi Nicholls kicked at the lion and screamed for help, the animal, said Hjelle, "grabbed the left side of my face, one of his fangs just below the bridge of my nose…As he closed down, I could feel my cheek tear away. I didn't feel pain. The lion didn't make a sound." Then the lion clamped onto her throat, and she passed out. At that point, three more bikers arrived and pelted the lion with stones until he moved off. Airlifted to a hospital, Hjelle underwent six hours of surgery; remarkably, although she lost blood and had nerve damage, none of her injuries were life-threatening. "I'm just so thankful to be alive," she said later. "Literally to have been in the jaws of death and live is incredible. "

ANIMAL ATTACK!

FACE OF COURAGE

Allena Hansen was outside working on her mountaintop ranch in Caliente, Calif., when a young black bear leaped from a thatch of willows, grabbed her by the head, bit into her face and spat out her teeth. "It sounded like when I bite into a stalk of celery, only infinitely more resonant," Hansen recalled later. At 5'1" and barely 100 lbs., she was completely overpowered and essentially gave up hope. Then her two dogs jumped in to defend her, and she heard Deke, her mastiff, yelp in pain. "I thought, 'If Deke is willing to die for me, the least I can do is try to escape,'" says Hansen.

Thanks to the dogs, she did—tumbling down a hillside and, though nearly blind, finding her car and driving three miles to a firehouse. A lifelong animal lover, she says she has no ill feelings for the bear:

Hansen shortly after the attack (above) and fully recovered (left).

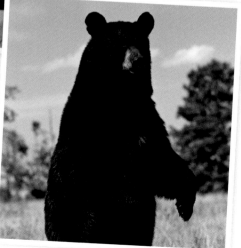

"It belongs here, it lives here." Her chosen lesson? "Given how much misfortune and terror there is," she says, "I tell people that if a little old lady can make it through a bear attack, you can too."

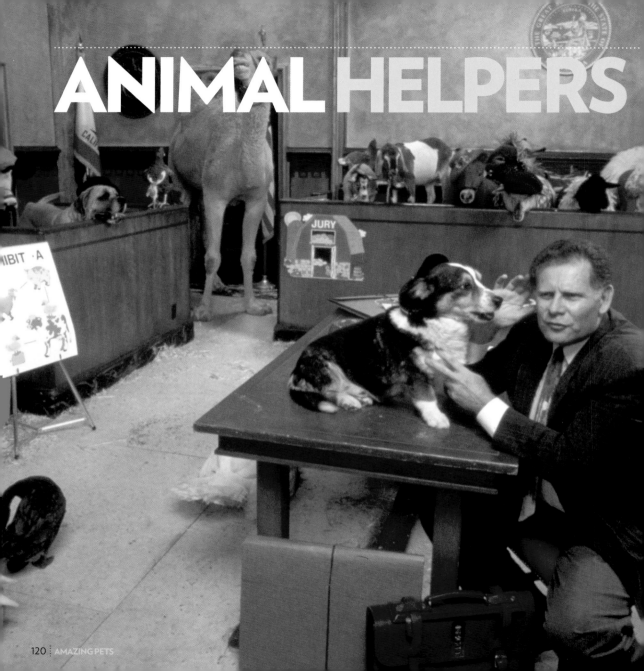

ANIMAL HELPERS

You've got a friend: When a camel goes to court, a pig needs a home or a K-9 vet needs love and therapy, some humans have very big hearts

DOGGED DEFENDER

"When lawyers think their cases are going to the dogs, they send for me," said attorney Michael Rotsten (photographed for PEOPLE in 1996). Working from an office in Encino, Calif., he runs one of the only practices in the nation devoted exclusively to dogs, cats, livestock, birds and just about anything with a heartbeat that isn't identifiably human. After an early career spent representing prostitutes, drug dealers and worse, he switched to animals and never looked back: "With animals, you like them and they like you. There's none of the usual B.S." Cases range from bites and noise issues to a woman who owned 60 Chihuahuas (56 beyond L.A. county's legal canine limit), with referrals often coming from animal-rights groups and fellow lawyers. Noted Rotsten: "They say, 'Let's get the guy with the cat hair on his suit.'"

THE MUTT
AND THE MARINE

BATTLEFIELD BUDDY

"The moral," says Maj. Dennis, who wrote a book about his canine pal, "is that if you do someone a 'solid'—animal or person—you get a friend forever."

One was the leader of an 11-man U.S. Marine counterinsurgency force on the Iraq-Syria border. The other, the scrappy leader of a pack of wild dogs living in abandoned ruins and subsisting on garbage. In October 2007 they bonded quickly over a shared MRE (Meal Ready-to-Eat). From then on, for the next four months, the dog, now called "Nubs" for his cropped-short ears, would show up whenever the Marine, Maj. Brian Dennis, returned. "There's definitely a special bond between those two," said Staff Sgt. Joseph Palomo. "Major Dennis has an open heart." But when the U.S. troops left the area for good, man and mutt were separated.

But not for long. Even though the team had moved 75 miles to a new camp, a Marine found Dennis and said, "You'll never guess who's outside."

"I thought, 'You've got to be kidding me!'"

"It's amazing how he has assimilated," says Dennis (with Nubs back home in San Diego, Calif). "He's a sweet pet who brings a lot of joy."

HE AIN'T HEAVY

"I didn't do anything special," says Dennis (with Nubs in Jordan). "But the dog did something amazing."

recalled Dennis. "It was Nubs, all bitten up with scars on his face from fighting. He had traveled some of the most nasty, inhospitable desert you can imagine. I have no idea how he did it. I looked at him and thought, 'This little guy has earned a trip to America.'"

The U.S. military, which forbids adopting strays but doesn't have an explicit rule about shipping them, might have disagreed. But Dennis kept his plan "below the radar," reaching out to family and friends back home and raising $5,000 to fund the trip. "He's a Marine, and once he has set his mind on something, he'll do it," said Palomo. "He wasn't going to leave Nubs behind."

Nubs arrived in the U.S. in 2008, a month before Dennis returned from his tour of duty. "When he saw me, he went crazy," says Dennis. "He was licking my face. It was fantastic."

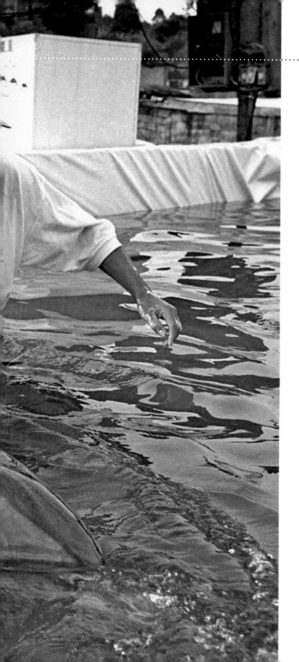

A DOLPHIN'S BEST FRIEND

For four years in the 1960s, Ric O'Barry was head trainer for the *Flipper* TV series, teaching the five dolphins who played the lead role to perform on camera. But the death of one of the principal dolphins, Kathy, in his arms in 1970 caused a radical change of heart. "The dolphin's smile is nature's greatest illusion," says O'Barry, who is convinced that the animal, depressed by the restrictions and regimen of her life, simply let herself drown. "They aren't happy doing tricks."

Since that day, he has spent his life battling the theme park industry, freeing captive dolphins and trying to save the animals in the wild; his work was featured in the Oscar-winning 2009 film *The Cove*, which used hidden cameras to publicize the annual slaughter of dolphins in Taiji, Japan. "This work," says O'Barry, "is payback for my *Flipper* sins."

BLESSED ARE THE OSTRICHLINGS

It's not easy raising ostriches, whose eggs must be turned every six hours for 42 days. So the Oklahoma City Zoo turned the job over to 10 monks at the Holy Protection Orthodox Monastery in tiny Forest Park, Okla. They had the time, they were up early, and they had passion. The monks blessed each batch of eggs and decorated the nursery with icons of St. Mamas, who tamed alligators and lions with a glance, and Elijah the Prophet. "He was fed by ravens, and his story shows the close relationship between man and animal," explained the monastery's Father Arsenios. Hatchlings were sold at a nice profit to other zoos, adding nicely to the monastery's nest egg.

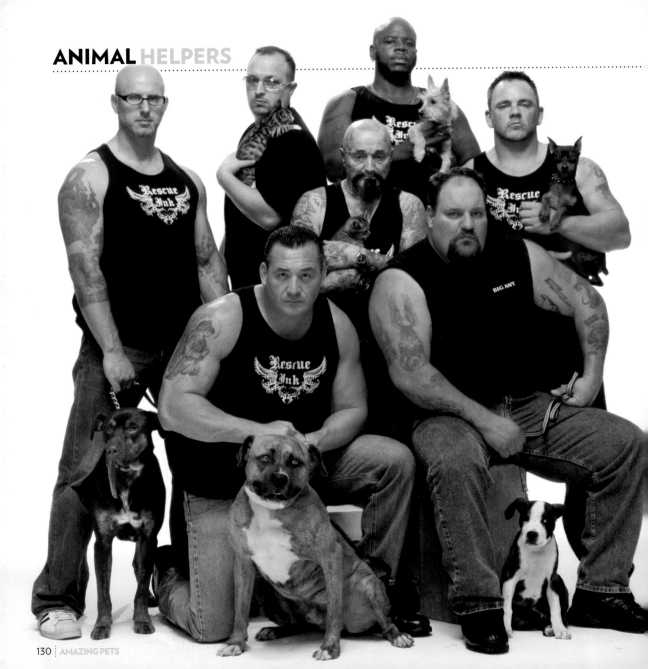

BEAR NECESSITIES

TOUGH GUYS, TENDER HEARTS

Since 2007, members of Rescue Ink, a group of New York City–area bikers with an unusual avocation, say they've delivered hundreds of abused and neglected animals to safety, as well as reuniting owners with lost or stolen pets.

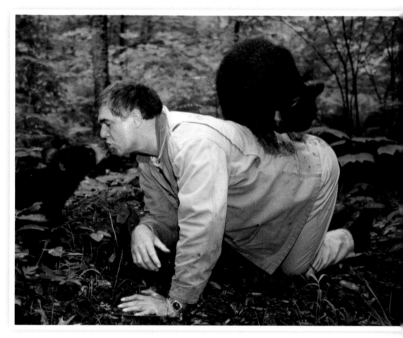

Using very hands-on—and, to some biologists, controversial—techniques, New Hampshire wildlife rehabilitator Benjamin Kilham taught orphaned bears how to live on the wild side.

TO SAVE THE WHALES

On Oct. 7, 1988, Roy Ahmaogak, an Alaskan Eskimo, reported seeing three California gray whales trapped in frozen seas near Point Barrow, an ever-shrinking patch of open water their only source of oxygen. A biologist was notified, who told a reporter. Soon footage of the whales struggling against the encircling ice, bashing their bloodied heads again and again on jagged edges and gasping for breath, landed on TV networks around the world, sparking a desperate race to save the behemoths. Eskimos, oil drillers and the Coast Guard stepped up to help; the Soviet Union offered an icebreaker; even President Ronald Reagan got involved, telling the U.S. National Guard, "Anything that we can say or do to help you along with the success of the operation, we'd be pleased to do." In the end—through a Herculean two-week effort that involved giant Skycrane helicopters, a 10-ton Archimedean screw tractor and teams of Eskimos cutting a four-mile chain of ice holes to open water—two of the three whales were saved. "We all started slapping each other on the back and cheering," said biologist Mark Fraker. "Man, oh, man, was it a high."

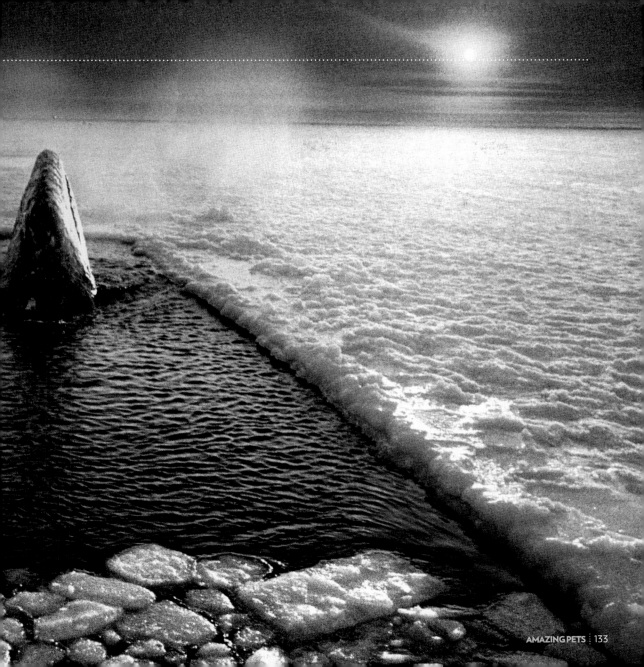

ARRIVEDERCI, AROMA

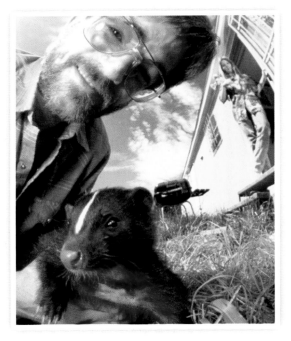

Jerry Dragoo, a world-recognized skunk expert, has an advantage over other skunkmaster wannabes: He has had no sense of smell. He does, however, have a deep love for all things black, white and furry. "They're pretty cool animals," says Dragoo. "They're small—but they're ferocious."

HOG HAVEN

Saddened by the plight of pet potbellied pigs—often abandoned by surprised owners when they grew to 300 lbs.—Sue Parkinson founded a California sanctuary, Li'l Orphan Hammies.

DANGEROUS PASSION

The bears," said Timothy Treadwell, "are my family," and it was close to literal truth. As a young man, he said, he was a misfit and he later battled drug and alcohol problems. Treadwell found solace with animals and, after first seeing a grizzly, developed a passion for living with, studying and, he said, helping protect the bears. Beginning in 1990, he spent summers camping among the grizzlies of Alaska's Katmai Peninsula with virtually no protection; when he encountered a bear, he would sing to it softly and lie down in the grass. The bears would usually walk away. Treadwell's life brought him fame—and criticism. "I think it's unwise to do what he does," said one grizzly expert. "He means well and he certainly cares a lot about bears, but if a bear kills or injures Timothy, the bear will probably be destroyed."

On Oct. 5 in his 13th summer living with the bears, Treadwell and his girlfriend were killed by a grizzly. Rangers encountered the bear at his campsite and killed it, along with a younger grizzly who charged at them. It was the first time anyone had been killed by a bear at Katmai National Park.

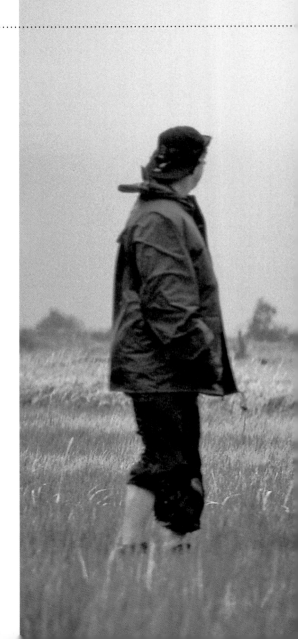

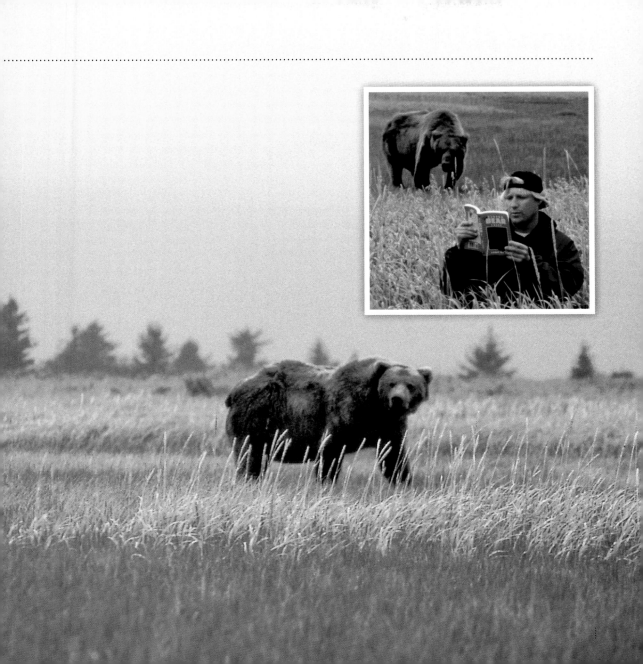

THE MILD,
MILD WEST

As she enters the pen at trainer Monty Roberts's Solvang, Calif., ranch, the roan filly whirls in fright. She's there to be broken to saddle, an ordeal that can take weeks and involve ropes and whips. Instead, by squaring his shoulders, making eye contact and using other subtle movements—mimicking, he believes, the language horses use among themselves—Roberts has the horse calmly accepting her first rider in an astonishing 28 minutes. "A good trainer can hear a horse speak," says Roberts. "A great trainer can hear him whisper."

Dismissed by other trainers for years as a flaky version of Doctor Dolittle, Roberts found his credibility soaring in 1989 after Queen Elizabeth summoned him to Windsor Castle to demonstrate his technique. She immediately enlisted him to train 16 calvary horses, as well as some racehorses for the Queen Mother. His methods, said royal groom Terry Pendry, are "just superb. He keeps being invited back. I don't think I need to say more."

CELEBRITY PETS

Kristen Chenoweth
and Maltese Maddie

Why the special bond? They're always happy to see you; they're cuter than any accessory; and they almost never, ever talk to the tabs

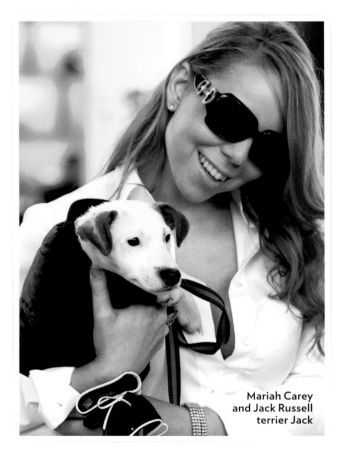

Mariah Carey
and Jack Russell
terrier Jack

Blake Lively and
Maltipoo Penny

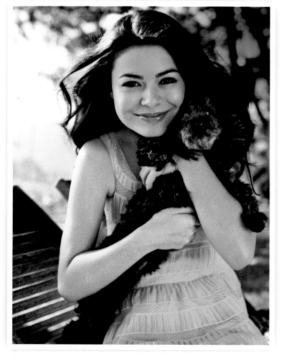

Miranda Cosgrove and toy poodle Pearl

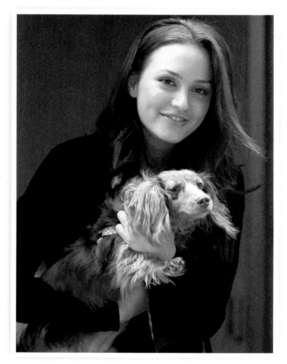

Leighton Meester and longhaired dachshund Trudie

TWO CUTE

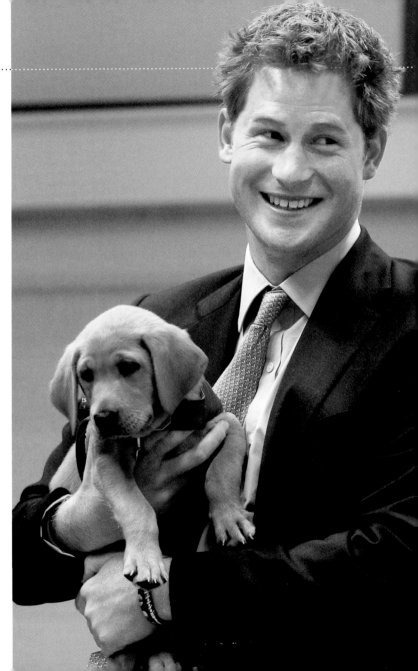

Puppies are cute. Prince Harry is cute. No problem so far. But what would happen if Harry was photographed *with* a really cute puppy? Would royals fans go into cuteshock? Could the image, all by itself, cause cavities? To widespread relief, the photo was released in 2010 to no significant ill effect. Which still left scientists wondering: What would happen if Harry were photographed with a really cute *kitten*?

PARISIAN PRINCESS

Paris Hilton's much-photographed Chihuahua Tinkerbell, the original pet-as-accessory, wrote her own book and inspired doggy T-shirts.

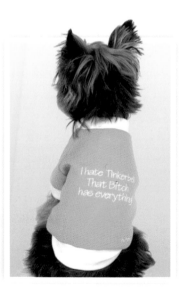

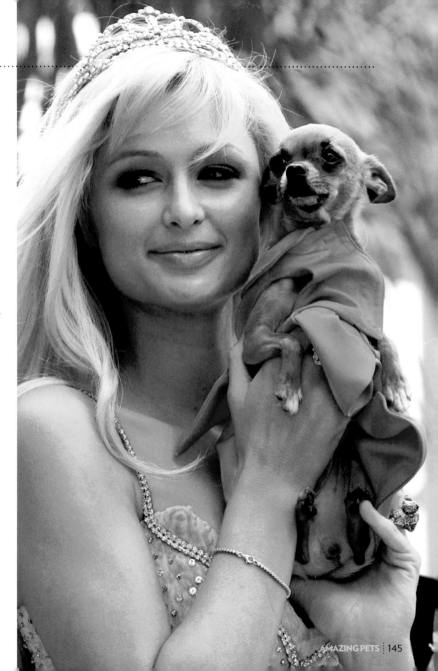

STRUT WITH YOUR MUTT!

Hey! I'm a good-lookin' pooch!
Why *else* would there be a guy
with a camera following us?
Head up! Shoulders back!
Walk *tall*. Walk *proud*.

George with
Ryan Gosling

Esmerelda, with Anne Hathaway

Chief, with Kelly Bensimon

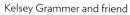

Kelsey Grammer and friend

Buttermilk, with Ashley Judd

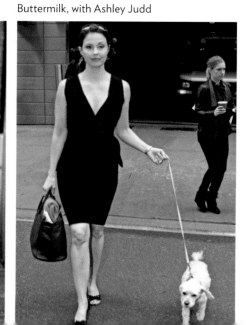

Kim Kardashian smooches a small but pulchritudinous porker at her nephew's birthday party.

PET PDA

Who doesn't like a little nuzzle on the muzzle—or snout?
Celeb's public displays of affection show big love to small critters

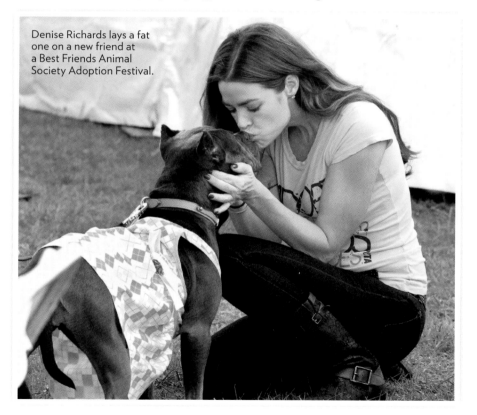

Denise Richards lays a fat one on a new friend at a Best Friends Animal Society Adoption Festival.

PET PDA

Ace, Carrie Underwood's rat terrier, wore a pink tuxedo to her wedding.

WITH TONGUE!

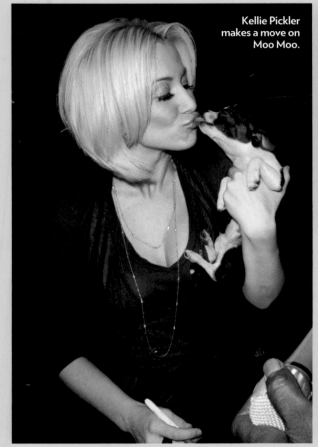

Kellie Pickler makes a move on Moo Moo.

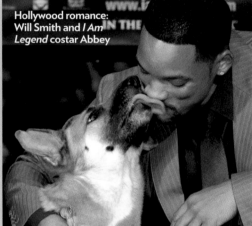

Hollywood romance: Will Smith and *I Am Legend* costar Abbey

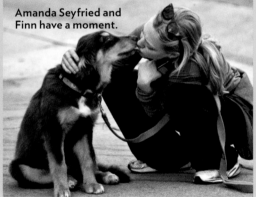

Amanda Seyfried and Finn have a moment.

WORKOUT BUDDIES!

Dogs as training pals? Not so good with free weights, but when it's time for a jog, they're the ideal, never-say-no running mate

John Legend and Puddy show off their pecs.

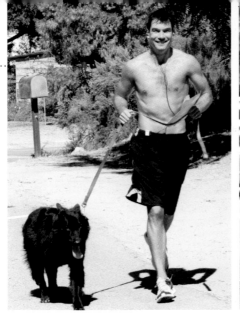

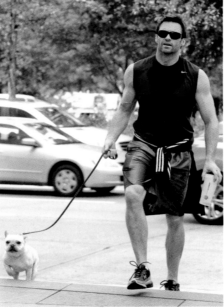

Jerry O'Connell and Bim feel the burn.

Hugh Jackman and Peaches

Kellan Lutz and Kevin step it up.

Famke Janssen and Licorice

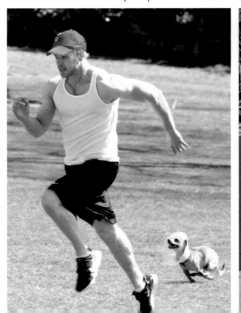

PET CELEBRITIES

He was Marley to moviegoers in the 2008 film *Marley & Me*, but at home in Venice, Calif., he's just Clyde. "Toys are his focus in life," says trainer Mathilde de Cagny. Also trips to the beach, the pool … a puddle. "If there's a body of water," says trainer Mark Forbes, "he's in it."

*Yes, there are some roles that even
DeNiro can't play*

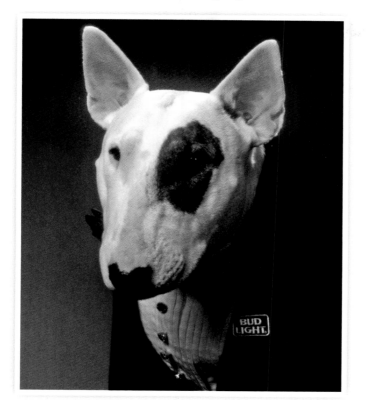

Bud Light's famous spokesdog, Spuds MacKenzie, was actually a female named Honey Tree Evil Eye. Reps worked hard to hide her true gender, even shielding her with their coats when she answered the call of nature.

The top human prize at the Cannes Film Festival is the Palme d'Or; Uggie, star of *The Artist,* was awarded the Palm Dog.

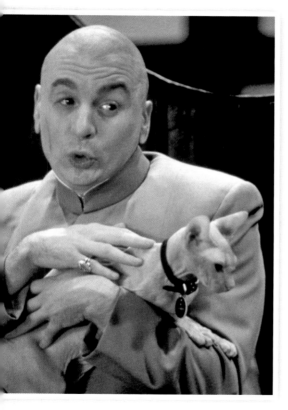

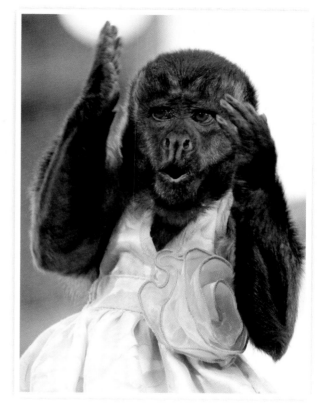

Dr. Evil's pet, Mr. Bigglesworth, was played by Ted NudeGent, a hairless Sphynx cat. What's actor Mike Myers really like? The Sphynx isn't saying.

Crystal, the scene-stealing capuchin monkey from *The Hangover Part II*, has appeared in more than 20 films and, at the film's premiere, walked the red carpet like the pro she is.

PUPPIES, PUPPIES, PUPPIES!

Australian Natasha Clarke's white German shepherd gave birth to a lot of pillows—er, puppies—in 2009. Can you count how many? A hint: The answer equals Justin Bieber's age, minus the number of books in the *Twilight* series, multiplied by the number of Oscars won by Julia Roberts. Hint No. 2: It's also 10 less than the brood listed in the *Guinness World Records* as the largest-ever litter (see answer below).

Answer: Fourteen

Editor Cutler Durkee **Design Director** Andrea Dunham **Photo Director** Chris Dougherty **Photo Editor** C. Tiffany Lee-Ramos **Designer** Joan Dorney **Cover Design** Cynthia Rhett **Writer** Alan Smithee **Reporters** Mary Hart, Ellen Shapiro **Copy Editor** Will Becker **Scanners** Brien Foy, Salvador Lopez, Stephen Pabarue **Group Imaging Director** Francis Fitzgerald **Imaging Manager** Rob Roszkowski **Imaging Production Managers** Romeo Cifelli, Charles Guardino, Jeff Ingledue

Special thanks: Céline Wojtala, David Barbee, Jane Bealer, Patricia Clark, Margery Frohlinger, Suzy Im, Ean Sheehy, Patrick Yang

TIME HOME ENTERTAINMENT
Publisher Jim Childs, **Vice President, Business Development & Strategy** Steven Sandonato, **Executive Director, Marketing Services** Carol Pittard, **Executive Director, Retail & Special Sales** Tom Mifsud, **Executive Publishing Director** Joy Butts, **Director, Bookazine Development & Marketing** Laura Adam, **Finance Director** Glenn Buonocore, **Associate Publishing Director** Megan Pearlman, **Assistant General Counsel** Helen Wan, **Assistant Director, Special Sales** Ilene Schreider, **Book Production Manager** Suzanne Janso, **Design & Prepress Manager** Anne-Michelle Gallero, **Brand Manager** Michela Wilde, **Associate Prepress Manager** Alex Voznesenskiy, **Associate Brand Manager** Isata Yansaneh, **Editorial Director** Stephen Koepp, **Editorial Operations Director** Michael Q. Bullerdick

Special thanks: Christine Austin, Katherine Barnet, Jeremy Biloon, Susan Chodakiewicz, Rose Cirrincione, Lauren Hall Clark, Jacqueline Fitzgerald, Christine Font, Jenna Goldberg, Hillary Hirsch, David Kahn, Amy Mangus, Robert Marasco, Kimberly Marshall, Amy Migliaccio, Nina Mistry, Dave Rozzelle, Adriana Tierno, Vanessa Wu

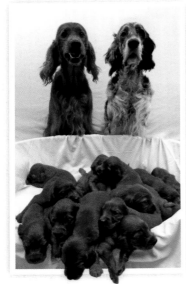

FRONT COVER
(clockwise from top) Craig Borrow/Newspix Rex USA; Alison Dyer; Julian Wolkenstein/Landov; Solent News/Splash News; Kirsty Wigglesworth/PA Photos/Abaca USA

CONTENTS
2-3 Gregg Segal

GALLERY
4-7 Julian Wolkenstein/Landov(3); 8-11 Solent News /Splash News(3); 12-13 Tom Sanders/Aeriel

Focus; 14 Ronald Cohn/AP; 15 D.Gorton; 16-17 Carlo Allegri/Getty Images(2); 18-19 Mavrix(2); 20-21 Harry Benson; 22-23 Mimi Cotter; 24 John Huet; 26 Eric Larson; 27 Kevin Horan/Getty Images; 28 Steve Northup/Getty Images; 29 Barm/Fame

HERO PETS
30 Brian Smale; 31 Juergen & Christine Sohns/Getty Images; 32 Acey Harper; 34-35 David Paul/Morris(2); 36-37 Keith Philpott; 38-41 Michael Sharkey(2); 42-43 Taro Yamasaki; 44 Ann States; 45 Michael Sharkey; 46-47 Kirsty Wigglesworth/AP; 48-49 Matthew Mahon(4); 50 Todd France; 52-53 Michael Carroll; 54-55 Michael Sharkey; 56-57 Erica Berger

SPECIAL FRIENDS
58-59 Craig Borrow/Newspix/Rex USA; 60 Courtesy The Elephant Sanctuary in Tennessee; 61 Barm/Fame; 62 Greg Wohlford/Erie Times-News/AP; 63 Dave Siddon; 64-65 Barm/Fame

PET SURVIVORS
66 Acey Harper; 69 Jason Wallis; 70 Ken Ige/Reuters; 71 Ronen Zilberman/AP; 73 Daryl Wright/Newspix/Rex USA

LOVE & MONEY
74-75 SDFL/Splash News(3); 76 Najlah Feanny/Corbis; 77 Remi Benali/Corbis; 78-79 Mark Peterson/Redux; 80 Texas A&M University/AP; 81 Steve Jones

ANIMALS IN THE NEWS
82-83 John Zich/TLP/Getty Images; (inset) Robert Allison/Contact Press Images; 84-85 Greg Ruffing/Redux; 86 Christopher Clark/Courtesy Department of Conservation Te Papa Atawhai; 87 Piers MacDonald; 88 Steve Labadessa; 89 Colin Murty/Newspix/Rex USA; 90 Mary Altaffer/AP; 91 Acey Harper; 92 Courtesy Karla Zimonja/The Alex Foundation; 93 Mike McGregor; 94 Manchester Evening News Syndication(2); 95 Andrew Tauber/Newspix/Rex USA; 96 Jensen Larson; 97 Courtesy Ernest Hemingway Collection, John F. Kennedy Presidential Library and Museum; 98-99 Courtesy Cross Films, Seattle(5); 100-101 Barbara Laing/TLP/Getty Images(2)

PETREPRENEURS
102-103 Stephen Ellison/Corbis Outline; 104-105 Todd France; 106 Dennis Mosner; 107 Jeffrey Lowe; 108 Keith Philpott; 109 (from left) Dennis Mosner; Steve Labadessa; 110 Todd France; 111 Courtesy William Secord Gallery

LOVE ME, LOVE MY...
112-113 Paul Weinberg(2); 114 Courtesy Shreve Stockton/The Daily Coyote; 115 (from left) Splash News; David Caird/Newspix/Rex USA

ANIMAL ATTACKS
116 Dana Fineman; 117 (from left) Courtesy Anne Hjelle; Darrell Gulin/Corbis; 118 Meredith Jenks; 119 (from left) Courtesy Allena Hansen; Tom Brakefield/Photodisc/Getty Images

ANIMAL HELPERS
120-121 Mark Sennet(2); 122 Courtesy Brian Dennis; 123 Coral von Zumwalt; 124-125 Courtesy Brian Dennis; 126-127 Wesley Bocxe/The Image Works; 128-129 Ed Lallo; 130 Andrew Brusso; 131 Robert Caputo/Aurora Photos; 132-133 Taro Yamasaki; 134 Chip Simons; 135 Jan Sonnenmair; 136-137 Phil Schofield(2); 138-139 John Storey

CELEBRITY PETS
140 Albert Michael/Startraks; 141 INF; 142 Dara Kushner/INF; 143 (from left) Jim Wright/Corbis Outline; INF; 144 Kirsty Wigglesworth/PA Photos/Abaca USA; 145 (right) LDP Images; 146 Splash News; 147 (clockwise from top left) Jackson Lee-Ahmad Elatab/Splash News; INF; Felipe Ramales/PCN; Team TC/Splash News; 148 Albert Michael/Startraks; 149 VPX/Broadimage; 150 Simone & Martin Photography; 151 (clockwise from left) Nikolay Ignatovich/MAXA/Landov; Gabriel Bouys/AFP/Getty Images; Bauer-Griffin; 152 Flynet; 153 (clockwise from top left) SS/Flynet; Hector Vallenilla/PCN; X 17; Splash News; 154 Alison Dyer; 155 Eric Heinila/Shooting Star; 156 Gregg Segal; 157 (from left) Photofest; Krista Kennell/SIPA

PUPPIES!
158-159 Mike Keating/Newspix/Rex,USA 160 Mikael Buck/Rex USA

BACK COVER
Solent News/Splash News